PHILIP EVERGOOD

20
years

EVERGOOD

J. Pierpont Morgan
Book Fund

 303

A C A Gallery Publication

distributed by: *Simon & Schuster*

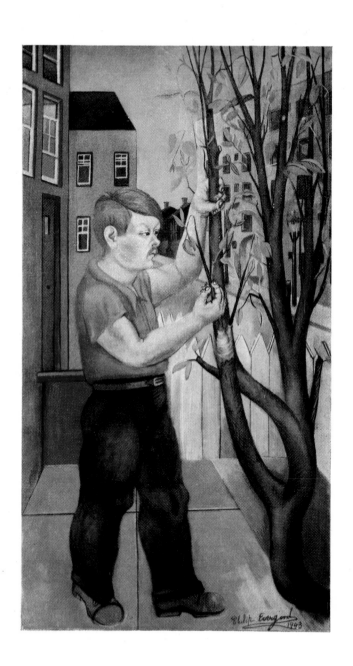

OUT OF THE FOG
 Collection Mr. and Mrs. Gustave Kellner (Color Plate)

Self Portrait — 1943

CONTENTS

	Page
OUT OF THE FOG — Self Portrait (color plate) *Collection Mr. & Mrs. Gustave Kellner*	6
FOREWORD BY HERMAN BARON *Director ACA Gallery*	11
THE HUMANIST REALISM OF PHILIP EVERGOOD *by Oliver Larkin, Professor of Art Smith College*	14–23
TURMOIL (color plate) *Collection Joseph H. Hirschhorn*	24
STATEMENT BY PHILIP EVERGOOD	25–27
LIST OF PAINTINGS REPRODUCED	29–33
REPRODUCTIONS (1929–1946)	34–89
WORKS IN PUBLIC COLLECTIONS	90
PRINTS IN NATIONAL COLLECTIONS	91
LIST OF PRINTS AND LITHOGRAPHS	92
LIST OF MURALS AND ILLUSTRATIONS	93
ONE-MAN EXHIBITIONS	94
AWARDS RECEIVED	95
CHRONOLOGY	96–102
LIST OF WRITINGS BY PHILIP EVERGOOD	103
TALKS, LECTURES AND RADIO BROADCASTS	104–105
BIBLIOGRAPHY: *Catalogues, Books, Special Articles, about the work*	106
CHRONOLOGICAL TABLE OF IMPORTANT REVIEWS	107–108

ACKNOWLEDGMENT

Grateful acknowledgment is hereby given to two friends of the artist, Irene Rice Pereira and Frank Kleinholz, without whose energetic help and good counsel this book would not have been made.

Also to Julia Evergood, whose work on the research was invaluable.

Herman Baron

FOREWORD

I MET PHILIP EVERGOOD at an Artists' Union meeting. His paintings often made me think of Poe and Whitman; and anyone who could combine the weirdness and imagination of Poe and the strength and freedom of Whitman certainly was someone to admire. In the flesh he seemed to fit the vague mental picture I had of him: robust, with full, round cheeks and a voice that booms and yet is gentle; eyes that are alert and meet yours unflinchingly, he comes forward to meet you with a burst of energy and good fellowship.

Evergood is a splendid lecturer and an unusual writer. If he were not a painter, I am convinced he would have been one of our finest writers. He is very articulate; and because of his loyalty to ideals and friends, what he has to say, on canvas or paper, has that clear, vibrant ring of truth and vitaliy.

His first one-man show at the ACA Gallery opened on February 20, 1938. I felt very proud of it and printed the first ACA illustrated catalogue. In that exhibition the deepening maturity, individual humor, warmth and human feeling expressed in his social paintings, left a lingering impression.

In the intervening years, he became ever more rooted in the world about him and fused the vigor and vision of the new with the sturdiness and abundance of the past.

An art critic who has written more and oftener about Evergood and understands him perhaps better than most others, is Elizabeth McCausland. In an article in the Springfield Republican she wrote:

> *"Evergood is an admirable proof of the catholicity of style and subject possible to social realism. His is by no means a naturalistic style like Meissonier's; he does not paint only subjects of social strife. But his conception of reality is soundly based on the external world. Not the private wars of the soul engross his brush, but the broad movements of life in society.*

"Not the private wars of the soul engross his brush" is a happy phrase. By all the evidence of his very early work, Evergood did drift to the "soul." His social point of view, however, saved him; for today the road to the "soul" leads to sterility.

It is with great pride that the ACA Gallery presents this volume, published in conjunction with Evergood's comprehensive exhibition of twenty years' work. Here is an artist who expresses the aspirations of the people of his country and therefore is making a universal contribution.

HERMAN BARON
Director, ACA Gallery.

New York, March 1946.

11

THE HUMANIST REALISM
of PHILIP EVERGOOD

by *Oliver Larkin*

THE SHEER IMPACT OF THESE EVERGOODS upon the senses may shock the casual and disturb the conservative, but neutrality will be as impossible for the observer as it was for the artist. There are over-all visual qualities in the group of paintings here assembled which, though they are means to more slowly perceived ends, provoke response from the beginning: the power and variety of the color, the never quite repeated reds of Evergood's brick walls, the blues which are sombre in *Mine Disaster*, vicious in the cops' uniforms of *American Tragedy*, luminous and clean in the sky over Stalingrad. Direct in their appeal to our touch and space-perceiving senses are these robust volumes in vigorously defined depth, the sturdy tensions between form and form, the movement which crowds a room or a street corner to its last inch, an enormous diversity of rhythm and an apparently inexhaustible vitality which suggest analogies with music.

Moving from picture to picture, one looks in vain for the recurrent and reassuring formula, for the well-tested cliché. There is no Evergood tree, no Evergood sky, but rather an astonishing originality of theme and of plastic invention which makes each work in some sense a new experience. There is joyousness hard to resist, explosive ridicule and fierce indignation. There is simple affirmation of plain realities, and there are undertones of fear, of dream and of fantasy. There are men and women, hundreds of them in these canvases, who stand as symbols but whom we also find ourselves remembering as people personally known,—the girl with the hidden apple, the child feeding sparrows, the Russian boy soldier, the fierce and tragic old lady whose forebears were pioneers.

Faced with complexity, one is tempted in the learned fashion of the Museum of

Modern Art to parcel Evergood into "periods": the classical-allegorical-biblical early phase; the *genre* of the late nineteen-twenties and early thirties; the "social" period which culminated at Richmond Hill in 1937; the anti-fascist work of the late thirties; the deeper personal emotion of the early forties. Sequences of this sort can mislead, and critics with a classification-complex will have their troubles with this man.

Twenty years ago, his first show produced two paragraphs in the *Times* which likened his compositional methods to those of the Italian Renaissance and his juxtaposing of colors to Cézanne. Six years later, he was called both classical and romantic. Two years after that, the same critic abandoned those terms and spoke of an exuberant and healthy enthusiasm, a prodigality "that sometimes lands him in the bog." Another commentator remarked that Evergood could no longer "safely" be described as a romantic, since he now attempted a "vigorously coarse and disturbing" social commentary. By 1942 there was general agreement only on the contradictions in his paintings. To one critic he was "gifted," to another "chaotic." One reviewer found *Juju as a Wave* "most distinctive,"—whatever that means,—and to another she was "gauche and tasteless."

Here at the A.C.A., with twenty years of his work before us, we can look for a consistency behind all this variety, and we can try to see the man whole, moving from sheer perception of his forms to their motivations in his personality and in his view of life and of art.* The zestfulness of those forms is the full, direct expression of a temperament with what Elizabeth McCausland has called "a compelling drive toward mirth and joy." Exuberance and prodigality are as truly to be found in the man as in the paintings; and so are the thirst for color, the affectionate and tender response to people, the quick fancy which sees matter for a picture in a newspaper caption, a friend's anecdote, an old woman glimpsed from a train window after a hurricane. Yet none of these, nor the tireless capacity for solving plastic problems, gives the key to his total meaning.

When Evergood wrote, "Sure, I'm a Social Painter," he meant more than the fact that, as President of the Artists Union and as Supervisor of a Federal Art Division, he had proved his concern for larger issues, had championed strikers and Spanish Loyalists. In his own articles and in the talk he gave to Smith College students in the Summer of 1944, he has made clear his view of the artist's continuity with others, his

*Elizabeth McCausland was the first critic to analyze the painter's development, in *The Plastic Organization of Philip Evergood*: see *Parmassus*, vol. XI, no. 3, March 1939, pp. 19-21.

15

"right to be as much a part of life as the miner, the steelworker or the College professor." He speaks of the masters who achieved this relationship in the past,—the Giotto who painted *Herod's Feast* in Santa Croce and the Fra Angelico of the Cortona *Annunciation*. Closer to his own intention were Bosch and the Elder Breughel with their "robust earthiness, passion for nature and fervent love of life"; and El Greco whose "tenuous forms with their sombre shading, with their vitriolic clashes and sharp stabs of color, with their incisive biting line of a wirelike sharpness, and with their soft glow radiating from the faces of the people, reflect his inner warmth and tender sadness in a world of uncertainty."

The earthiness of Breughel is in Evergood's swarming street scenes, and something of the strange inventions of Bosch in *Quarantined Citadel*. El Greco's "soft glow" radiates from the face of his boy veteran, and the Spaniard's gaunt forms reappear in *The Letter*. Such parallels are less important than the fact that this world too, for Evergood, is a world of uncertainty, of struggle and conflict, of death and destruction, but also a world of hope. He believes it is the painter's task to re-establish his connection with this world, neither in terms of hatred nor by passive imitation of her shapes, but affirmatively through belief in the human creature. The older naturalism, as Louis Aragon once observed, was dominated by the search for pictorial illusion; the new realism will use that "nature" which all men experience in common in order to enrich and deepen men's understanding of themselves and their world. As Evergood has written, the language for this new conception of reality is still evolving and its expression is still incomplete, but the issue is no longer between representation and non-representation; it is between humanism and formalism. The socially-minded artist is trying to re-educate himself, and Evergood concedes that, from the purely formal point of view, the result is at times less satisfying than that of the old academic hack. But he has at least discovered that there can be no separation between form and content; the two are one, "as a living man and life are one, or the earth and sun, or the flying bird and the wind." He has also discovered that "there is plenty of scope for invention in this vast universe of objectivity." Secure of purpose, he can borrow freely from the great past, or make fruitful use of the new revolutionary forms and intensities in his effort to accomplish what Evergood calls "the prodigious feat of combining art, modernity and humanity."

The painter adds that "the feat can be accomplished today as it was yesterday by

those who have the strong attributes of an artist, combined with patience, intelligence and resolve. A few times I have done it." And who will deny, on the evidence here presented, that he has done it more than a few times? Few indeed have been the occasions when his form-making skill has lagged behind his intention or run ahead of it, when he did not allow his first vision time enough to phrase itself in terms which would convey it to the rest of us. Van Gogh once remarked how hard it was for the mind, the feelings and the hand of the artist to keep pace with one another; and many a painter knows what the Dutchman meant by "sheer work and calculation, with one's mind utterly on the stretch, like an actor on the stage in a difficult part, with a hundred things at once to think of in a single half-hour." There are paintings by Evergood in which the desire to clarify, to insist, results in over-emphasis. There are a few whose powerful tensions he could establish but not resolve. There are spaces insufficient to hold their human content, where an occasional figure seems to have arrived too late on the scene to find room in the artist's expression. Here and there is a human head which, because Evergood has not quite succeeded in concentrating upon it his knowledge, his insight and his affection for the human being, has become grotesque. All these are healthy failures because they result from the occasional inadequacy of the means to the end; this painter has never sought to adapt the end to the means. Too many artists avoid what would strain their technical powers, and, having developed a personal and marketable "style," keep safely if tiresomely within its established limits. More than one naturalist is caught in the meshes of his own dexterity; more than one non-objectivist has curled up comfortably on his formal treasure, as Aragon said, the sluggishness of his pictorial meditations undisturbed by the great upheavals of our time; having combined art with modernity, he rests content. Evergood's effort to absorb experience not into his brain but into his entire being, reaches further and deeper; and if he does not always fully grasp, are not his failures more successful than the failure of the "successful" to do no more than repeat themselves *ad infinitum?*

Compare the faintly conventional *Old Wharf* of 1934 with the fresh and deeply poetic landscape in *Mill Stream* of 1941. Contrast the brilliant but uncomplicated color of *Solomon and Sheba* with the subtle modulations of *Forebears.* Consider the fine solidity of naked Sheba, and the equally solid but infinitely more expressive realization of the girl with the hidden apple. And to take Evergood's measure as an architect of

forms, study his mural sketch of 1932, and then go to Richmond Hill Library where he completed a wall painting five years later. The first is a project in three panels with the title: *Towards Peace.*

Out of the imagination which created the early water colors has come the flying figure of the angel. Out of the artist's concern with his own world have come the clothed figures who mingle, not too comfortably, with the naked ones. The great tree whose branches spread from the center into the side panels holds them together in an all-compassing rhythm, and there is a lively dynamic felt throughout the design, in contrast to the listless, static quality of academic murals. Only the woman with the violin, the rather intrusive horses, and a bust crowded into a small space, are elements not fully assimilated to the whole.

The Story of Richmond Hill has also a triple theme, since Evergood chose to portray the wealthy benefactor and his associates who planned this garden community, the country pleasures and occupations of Richmond Hill, and the grimmer city life from which it offered a release. But here these three notions find a more complete integration: On the right side, the rigid horizontals and verticals of steel and cement, the confined spaces of life under the shadow of the Elevated; on the left, the relaxed and free movement of men and women under the open sky; mediating between these and resolving their antithesis, the founders of Richmond Hill. A fragment of wall and the plume of smoke from a locomotive punctuate this sentence and clarify its meaning. Two doors,—a dingy broken one on the right, a clean white one on the left,—open into the central space; here is an example of the profound originality which can make fresh and convincing symbols out of familiar objects. The young bodies of the country people swing in a round dance, their forms defined with what one local Puritan called "gross corporeal references," and what others may compare with the sculptural, healthy roundness of the Italian masters. There is an antithesis of colors too: the Richmond Hillers move among vigorous greens, clean blues, yellows and bright vermilions; in the shadowed city street, men go quietly to their work among dark blues, metallic greys and sombre browns. And who but Evergood would have thought of giving us, not whole people coming down the stairs of the El, but only their expressive feet and legs? In the mural's center, he has resolved his color-antithesis by repeating, in variation, the notes of both extremes. The wall orchestrates work and play, a young gayety and a tired

maturity, graceful linked motion with staccato; fields rolling toward a horizon with brick-confined sidewalks, the jocose with the grave, the dream with the reality. Here are no solemn posed abstractions but full-bodied personalities in a superb interplay of thought and action. No mural painter of our time has worked with a deeper sympathy for his theme, nor with a surer inventive skill for its expression.

The present exhibition reveals a man who at forty-five is "getting more mature" (the phrase is his) "in his relationships to other human beings." It reveals the nature of his relationship, in purpose and accomplishment, to the work of fellow artists,—regionalists, social painters, expressionists and probers of the unconscious.

When Evergood paints still life, for example, he neither manipulates the forms of fruit and flowers as plastic units, as do the followers of Cézanne, nor does he dwell on their objective beauties like a neo-Chardin. That extravagant bouquet in *Still Life* makes its own humorous comment on the withered, un-flowerlike faces of the man and woman beneath it; in *Expectation,* fruit on a table is the materialization of a child's hunger. Nor are his occasional landscapes "pure." The red-brown shafts of trees and the moist greens in *Mill Stream* evoke not so much the image of a place where people live as their affection for its odd blend of ugliness and charm. *Kalamazoo in Winter* is regional but not provincial. It was painted with that zest for the local and peculiar which enlivens many an American "view" of the nineteenth century, but also with a sense of the broadly characteristic, the typical, through which the particular becomes the universal. Again in *Suburban Landscape,* with its sober row of stunted and standardized houses against snow, the painter not only restates what each of us has seen from innumerable trains, but quietly suggests the life behind those yellow-shaded windows.

The American street has delighted artists since the days of the early Republic, and in our days one recalls John Sloan's affection for the crowds who move along the side-walk or pause before shop fronts, and his Daumier-like skill in rendering their pictorial and human qualities. One thinks of Kenneth Hayes Miller and his rather cold inventories of shoppers. Evergood's *Street Scene* is at once more explicit than Sloan, more sprightly and humorous than Miller; it has the jostling, raucous turbulence of Hogarth and some of that cockney's talent for making a complete individual of every man, woman and baby in the crowd.

Crowds have tempted Evergood on more than one occasion. In *Art On the Beach,*

however, in *Music* and in *Dance Marathon*, this crowd is never for him a compositional bloc to be pushed around on his canvas, nor a collection of supers trying to keep their place behind the principal actors. The crowd *is* his principal, and moves with a collective will which is more than the sum total of its separate energies. Both Paul Cadmus and Reginald Marsh have dealt with themes similar to *Art On the Beach;* their underlying resentment, their recoil from the sprawling anatomies of Coney Island, contrast with the humorous and healthy response of Evergood, and it is to them, rather than to him, that the critic should have applied his phrase of "vicious, somewhat farcical humanity."

It is no secret that Evergood stoutly champions humanity, and more especially that part of it which works with its hands in shops and factories and under the ground. His *Madonna of the Mines, American Tragedy* and *Toiling Hands* belong among the "social conscience" pictures; they are a part of that pictorial protest which, in the early thirties, was as forceful as it was timely. Some of it was mere illustration of a social theme,—the strike, unemployment, the racial question, the nearness of fascism. It is important to remember that the men and women who called the Artists Congress in 1936 were among the first Americans to see the menace to peace and to democracy when it was no bigger and no more conspicuous to most of us than Ethiopia. Some of them, trained in techniques and forms inappropriate to the new task, and driven by the urgency of the warning they had to express, failed to communicate that warning fully. In *An American Tragedy* Evergood went beyond illustration, beyond protest, because he found an imagery for his feeling, tensions for his clash of human forces, volumes and colors to convey his anger and his partisanship. Likewise, in pictures dominated by a single figure, he has personalized the social and centered the fears, the hope and the suffering of the many in the one. He concentrates the horror and also the heroism of a great moment in recent history in the face of a one-legged child who limps among the rubble of Stalingrad; and the strength of a great many women is in the pregnant girl who stands with such dignity on a slum stairway in *Turmoil.*

The humanizing touch is in this painter's factories, his mills and houses. Emerging long since from the veil of smoke which marked its first hesitant appearance in American art, the factory has inspired the delightful clean planes and fanciful inventions of Peter Blume and, at the opposite extreme, the cool perfections of Sheeler at River

Rouge. In Evergood's *Through the Mill,* a factory becomes a shabby framework for toil, and each of its many windows opens upon the life of the men and women who sit at its benches or stand before its machines; it was painted with no concern whatever to play with shapes nor beat the camera at its own game.

The Victorian house, so familiar to us in the work of Hopper and Burchfield, makes its appearance now and then in Evergood. Hopper's mansards and cast-iron finials glisten in the hard sunshine; Burchfield's affection for the gingerbread gloom of the eighteen-seventies drives him deeper below the surface, and he can express, not merely describe, the drab monotony of a street in a mining town. The odd mansion in Evergood's *My Forebears Were Pioneers* has neither the crisp immediacy of Hopper nor the warmly felt picturesqueness of Burchfield. On a lawn which the hurricane has ravaged sits an old lady in a rocker, ramrod straight, staring her defiance of disaster, her immunity to change. Beyond her the great boles of uprooted trees thrust back toward the ancestral house upon which one of them has fallen. And the house has the same battered dignity as the lady. Its colors are the faded yellows and dull greens of her own flesh. Like her, it is a symbol of bleak pride, of refined decay, not soon to be forgotten.

Or is it something quite different? Will it not suggest for some the contrast between pioneers to whom trees meant something to be cleared away and to be used for building, and their great-grandchildren for whom they guarantee a respectable privacy? Others will feel that Evergood has been poking fun at the D.A.R. mentality as Grant Wood did, but more trenchantly. For still others, he has felt and expressed the tragi-comedy of man's knack for averting extinction by the skin of his teeth. And this multiplicity of meanings is to be found in other works, where the title says one thing and the picture suggests another. Humor and horror strangely and disturbingly confront each other in *Ex-Soda Jerk. Lily and the Sparrows* is, on the surface, as naïve as any American primitive, yet its deeper emotional impact is far beyond the capacity of the sophisticated modern "primitive" whose adult infantilism tries to re-capture lost innocence. Paintings like these are the effort of the artist to communicate emotions which lie far below the mind's surface, and to do so, as he says, in a "subtly unphysical way." The strange confrontations, the paradoxes which result from this effort cannot be translated into words, and to indicate them is only to suggest undertones of dream, of fantasy, of pity and terror which trouble the mind yet somehow enrich, as the images of the Surrealists so sel-

dom do, our sense of common humanity. Many a modern artist, faced with the deep discrepancies between man's capacities and his achievements, stirred by his constructive skill and discouraged with his failure to make full use of what he has constructed, has imposed on his images of men the hard and logical perfections of non-living objects, re-creating the human in the image of the machine. Evergood has reversed this process, and like the Expressionists, by emotional transference has projected into inanimate nature the attributes of living things. It is the same interchange under whose impulsion Van Gogh painted the faces of his peasants with the color of a "good, dusty potato" in order to show how they had dug the earth with the very hands they put into the bowl on the table in *Potato Eaters*. So Evergood charges a brown wall with the bleakness in the mind of the workman who has just read his dismissal slip, or makes a brick one glow with the delight of Lily feeding her sparrows.

Consider his locomotives, and compare them with Sheeler's, which are complete to the last bolt and piston, sleek and all-sufficient. Compare them with the frenzied, snorting engines of Thomas Benton, which are toys. Those of Evergood are plump, sturdy, compact and full of power; they have the chunky and cheerful strength of the men in overalls whose life is their life, who climb over them and who stand beside them. They may be taken as proof of his conviction that man is indeed the measure of all things.

And the measure of Evergood must be the degree to which, despite the inadequacy at times of his language to his intended meaning, has meted and measured, in Whitman's phrase, for today and here. The author of *Democratic Vistas* announced that it was time for America sternly to "promulgate her own new standard, yet old enough, and accepting the old, the perennial elements, and combining them into new groups, unities, appropriate to the modern, the democratic, the west, and to the practical occasions and needs of our own cities and of the agricultural regions . . . the main thing being the average, the bodily, the concrete, the democratic, the popular, on which all the super-structures of the future are to permanently rest." Evergood, like Whitman, finds "ever the most precious in the common." Like Whitman, he has painted "the sprawl and fulness of babes," and "the play of masculine muscle through clean-setting trousers and waist-straps." He has pictured "the group of laborers seated at noon-time with their open dinner-kettles, and their wives waiting"; on his canvases are "the little plentiful manikins skipping about in collars and tail'd coats." He declares, with the poet,

This is the city and I am one of the citizens,

Whatever interests the rest interests me . . .

Speaking the language of the painter and not of the artificer of words, Philip Evergood has shown us the sons of Adam. What artist of these twenty years has reduced their pretensions to so affectionate an absurdity, or given us more haunting images of their despair? Few indeed, if any, have done more than he to heighten our sense of the worth and importance of the human adventure, to demonstrate the power of common men to build and create, and to remind us without too much solemnity of democracy's unfinished business.

Oliver Larkin

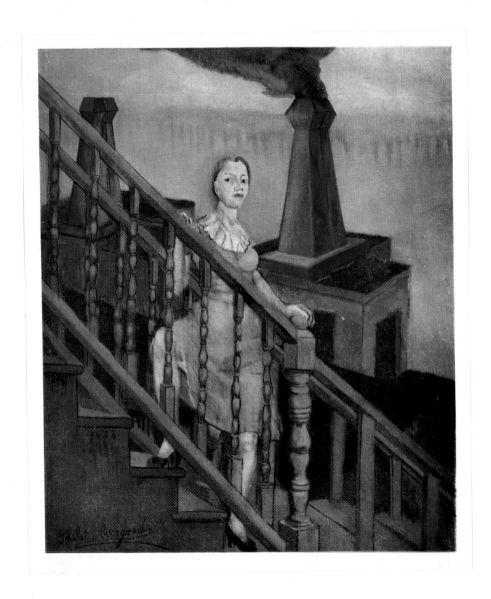

TURMOIL
Collection Joseph H. Hirshhorn (Color Plate)

24

Statement by Philip Evergood

"PEOPLE" IS TOO BROAD A TERM to be used in relation to an art audience. No artist can claim universal popularity or neglect. We live in a world of conflicting forces. On one hand we see gluttony and self-aggrandizement, and on the other self-abnegation, sacrifice, generosity and heroism, in different members of the same human race.

Diverse emotions stir in different humans when exposed to the same experiences and when confronted with the same objects. Compare the differences of reaction (both inner and outer) in separate individuals to the sight of a picket line, for example. The sleek member of the *haute monde* sunning her poodle, looks upon the picketers with hatred, fear and nausea, for they appear to jeopardize security and menace the pampered life which means the complete world to that individual. The unemployed worker with no coat and holes in his shoes is warmed by the sight of these marchers who are sacrificing the loss of wages to win a fight for better living conditions.

A work of art likewise appears in two utterly different lights under the scrutiny of two utterly different beings.

Different artists looking at the same phase of nature or the same bit of reality will also get completely different reactions. Common experience proves this con-

tinually. By obvious deduction it is reasonable to assume that the artist does inevitably select his own audience, consciously or unconsciously. He is a weakling if he tries to please everybody, and a fool if he expects to.

But if he has something very great to say, something universal or something so important to add to life that it surmounts his eccentricities of style, his audience will grow to mass proportions. His peculiarities in time will be accepted as virtues and even become tradition.

It is rare when the wrong target hops into the artist's field of fire, but it happens. Occasionally some steel worker or longshoreman will profess an addiction to the work of say Mondrian. It takes a Daumier to make a plutocrat crave to possess a painting which is a searing indictment of his class. In the last case time and death are certain to have contributed their share to the artist's powers of seduction.

Human nature follows the pattern of personal experience pretty closely. The creative nature of man is molded and rounded by it also. Man's mental standards and his esthetic ones are based on his powers of absorbing knowledge from an experience. He may absorb into the brain or into the entire being. A great artist does both, and more—he retains the memory of an experience even in his touch and is besides, able to impart the experience to others in a subtly unphysical way.

Odelon Redon, for example, touched a cobweb once, I can tell, and in his fingertips he retained that elusive memory of the sensation all his life. You can see it in the gossamer, elastic-like quality of his line. Perhaps he was hypersensitive; perhaps he was too precious; I don't know, but he experienced something subtle and set it down.

Rembrandt kissed the weather-beaten cheek of his old grandmother once, I can tell, and in his memory he retained the apple feel of the tight skin of her forehead and the downy wrinkled cheek with the rosy smear and the sharp tracery of etched lines around the eyes and the warm yellowish glow of the whole head. You can feel this in the tender living quality of all his old people

and in his young ones, too, for that matter—he simply retained a more vivid memory about something he had observed and felt than other men could.

What an artist puts into his work comes back to him. If he feels deeply about trees he will observe them keenly and in his canvases they will stand firm, and sway, and shimmer, and grow old, and rot and die, and the young ones will sprout out of the ground again. He will make the trees live and others who have loved and observed trees will feel them live in his canvases. That is how it will come back to him. He has experienced something important and he has made others conscious of how important his conviction is—even about trees. When an artist can do the same thing with human beings he is big and the greatest thing in life will come back to him. Sensitive people will see themselves in his work.

I feel the search of an artist should be for the richest and fullest of human experiences and that he should look for both the visual manifestations and those transmitted intuitively. The more the artist contacts the inner qualities of people the more he will understand Life and where he fits into it. The more mature he gets in his relationships to other human beings the more vital will be what he says in paint or stone.

Thoughts like these are very much a part of esthetics.

Philip Evergood

CATALOGUE

LIST OF PAINTINGS

SOLOMON AT THE COURT OF SHEBA	1929
TOWARDS PEACE *Mural Design Exhibited Museum* *of Modern Art Mural Exhibition*	1932
BURYING THE QUEEN OF SHEBA *Collection Denver Museum*	1933
MUSIC	1933
LITTLE ACCOMPLICES *Collection Kalamazoo Art Institute*	1934
THE OLD WHARF *Collection Brooklyn Museum*	1934
ART ON THE BEACH *Collection, National Gallery* *Melbourne, Australia*	1934
DANCE MARATHON	1935
THE SIDING *Collection Frank Kleinholz*	1935
STREET CORNER *Collection Himan Brown*	1935
MINE DISASTER *Collection Himan Brown*	1933-1936
THE LETTER *Collection Harry Abrams*	1937
*AMERICAN TRAGEDY	1937
LILY AND THE SPARROWS *Collection Whitney Museum*	1938
INNOCENTS ABROAD *Collection Mr. and Mrs. Sol Fishko*	1938
THROUGH THE MILL *Collection Whitney Museum*	1940
RAILROAD MEN'S WIVES *Collection Robert Gwathmey*	1933-1940
MY FOREBEARS WERE PIONEERS *Collection Mrs. Bruce E. Ryan*	1940
MILLSTREAM *Collection Harry Abrams*	1941
FAT OF THE LAND *Collection Boston Museum*	1941

KALAMAZOO IN WINTER 1941
 Collection Metropolitan Museum

NEW BIRTH 1941
 Collection Alfredo Valente

TURMOIL 1941
 Collection Joseph H. Hirshhorn (Color Plate)

LEAVE IT TO THE EXPERTS 1942
 Collection Arizona State University Museum, Tucson, Arizona

*OUTSIDE THE TENT 1942

*JUJU AS A WAVE 1935-1942

BOY FROM STALINGRAD 1943
 Collection John Davies Stamm

OUT OF THE FOG 1943
 Collection Mr. and Mrs. Gustave Kellner (Color Plate)

THE PRESTON EAST DOME MINE 1944
 Collection Joseph H. Hirshhorn

RUSSIAN MUSIC IN CENTRAL PARK 1944
 Collection Emil J. Arnold

*THE HERO 1944

MADONNA OF THE MINES 1932-1944
 Collection Mr. and Mrs. John Kotuk

DON'T CRY MOTHER 1935-1944
 Collection Museum of Modern Art

STILL LIFE 1944
 Collection Mrs. Juliana Force

THEY PASSED THIS WAY 1944

MURALS: BRIDGE TO LIFE 1940-1942
 Kalamazoo College, Michigan
 THE STORY OF RICHMOND HILL
 Public Library at Richmond Hill, Long Island
 COTTON FROM FIELD TO MILL
 U. S. Post Office, Jackson, Georgia

*Collection of the Artist

NEW PICTURES

ONE MEAT BALL 1945

THE QUARANTINED CITADEL 1945
 Honorable Mention Carnegie Institute

MEN AND MOUNTAIN 1945

COMRADESHIP 1945

NO SALE 1945

THE INDESTRUCTIBLES 1946

DAWN 1946

PORTRAIT OF MY MOTHER 1927-1946

HAPPY CHILDREN 1946

JOBS NOT DIMES 1946

ICE CREAM CONES FOR THREE 1946

WOMAN AND COCK 1946

THE BRIDE 1946
 Collection Mr. and Mrs. Marvin Small

A CUP OF TEA 1946

THE HIDDEN APPLE 1946
 Collection Lily Harmon

FREEDOM FROM FEAR 1946

HOME 1946

DESIGN FOR A BLACK LACE HANDKERCHIEF 1946

THE BLUEBIRD 1930-1946

SEEKING A FUTURE 1946

FASCIST FRANCO LEADS 1946

HEAD OF RAILROAD MAN 1946

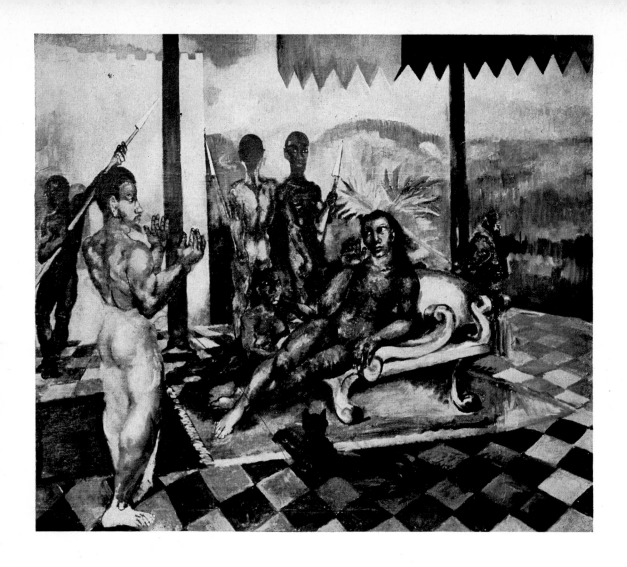

SOLOMON AT THE COURT OF SHEBA 1929

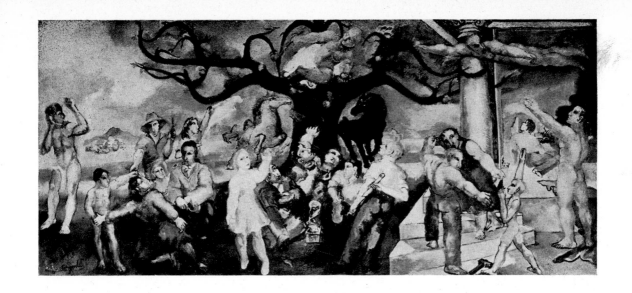

TOWARDS PEACE **1932**
 Mural Design Exhibited Museum of Modern Art Mural Exhibition

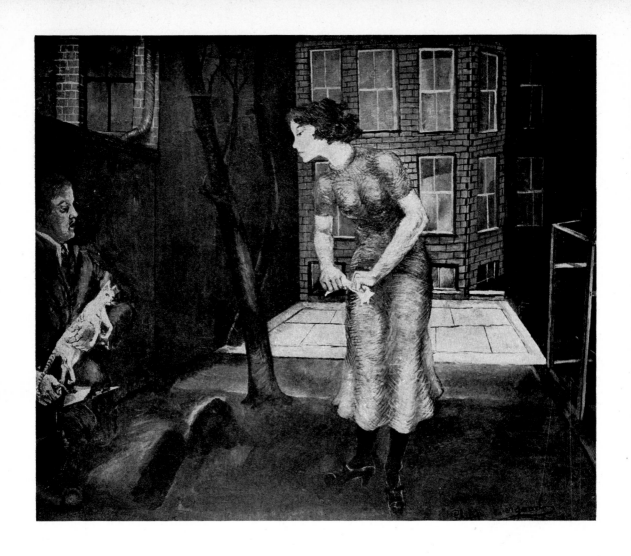

BURYING THE QUEEN OF SHEBA 1933
 Collection Denver Museum

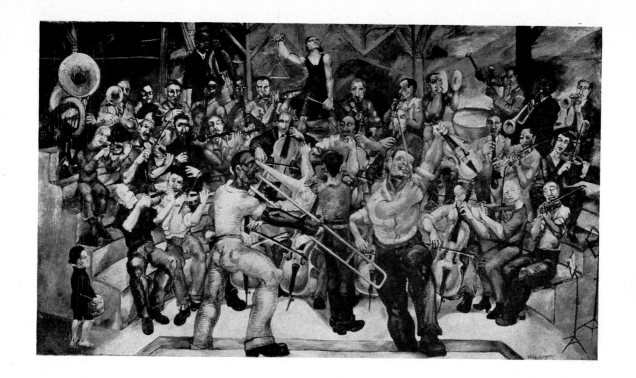

MUSIC 1933

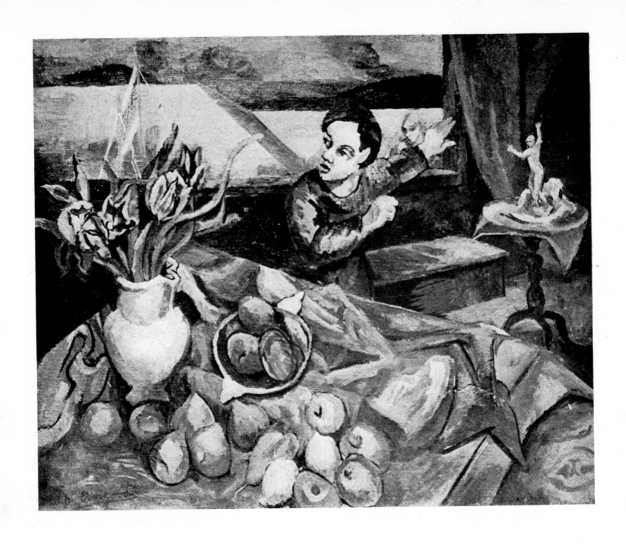

LITTLE ACCOMPLICES 1933
 Collection Kalamazoo Art Institute

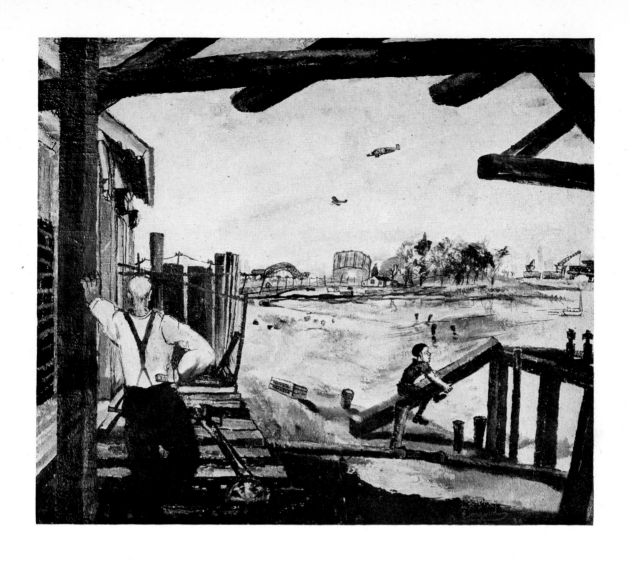

THE OLD WHARF 1934
 Collection Brooklyn Museum

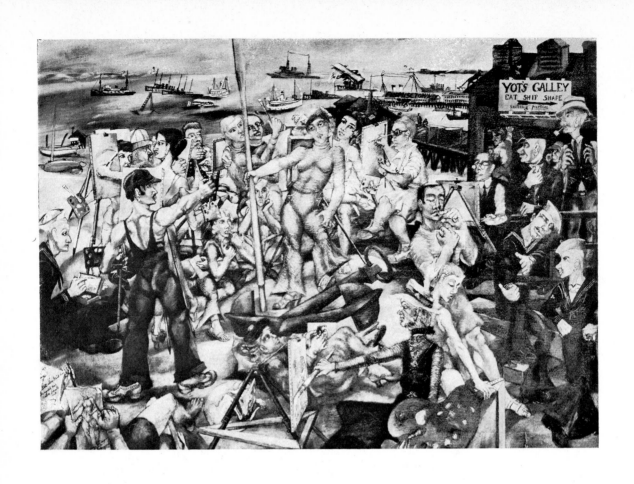

ART ON THE BEACH
Collection National Gallery, Melbourne, Australia

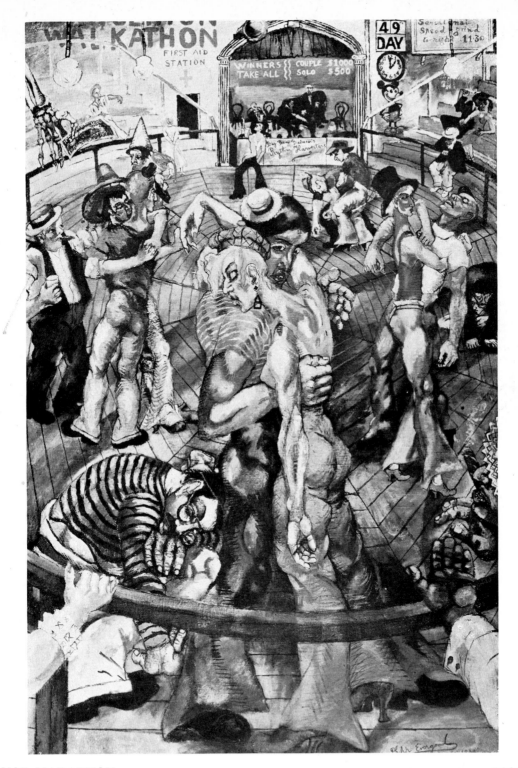

DANCE MARATHON 1935

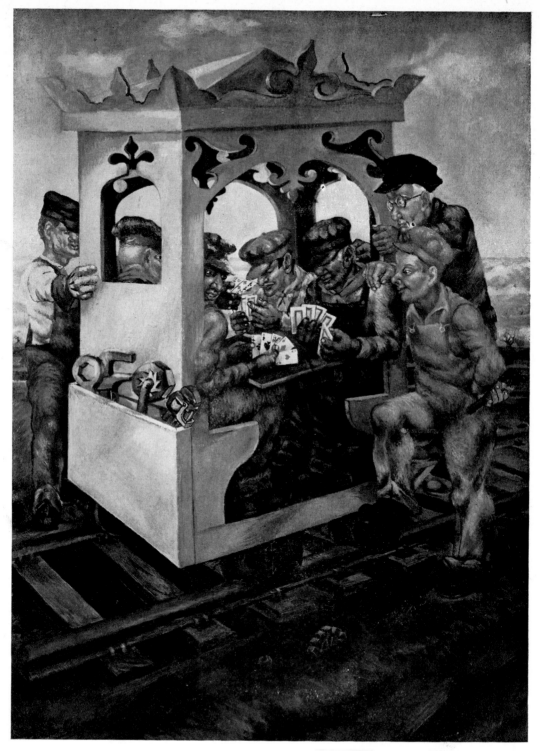

THE SIDING
Collection Frank Kleinholz

1935

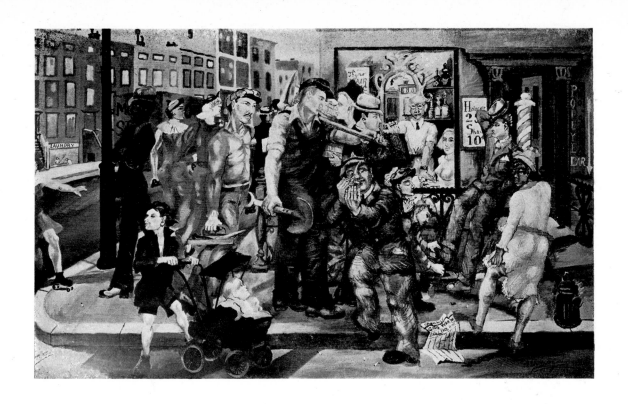

STREET CORNER 1935
 Collection Himan Brown

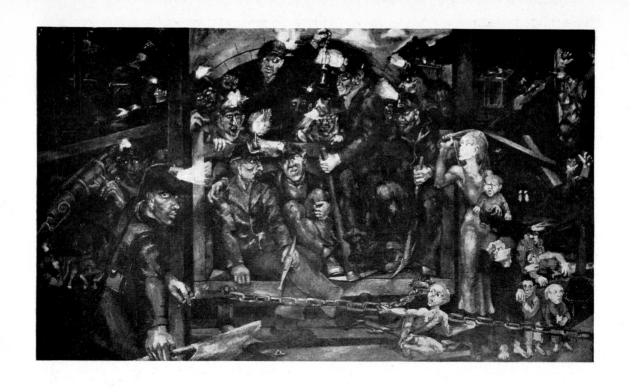

MINE DISASTER
Collection Himan Brow

1933 – 1936

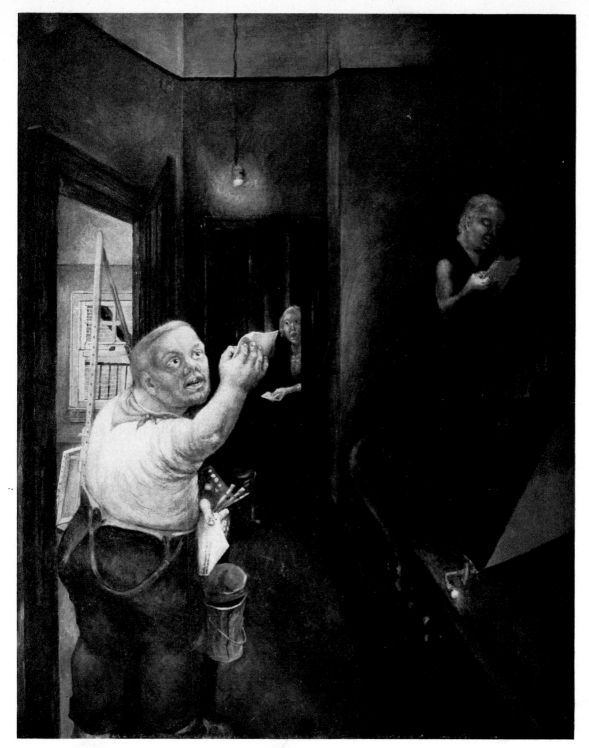

THE LETTER　　　　　　　　　　　　　　　　　　　　　　1937
　Collection Harry Abrams

45

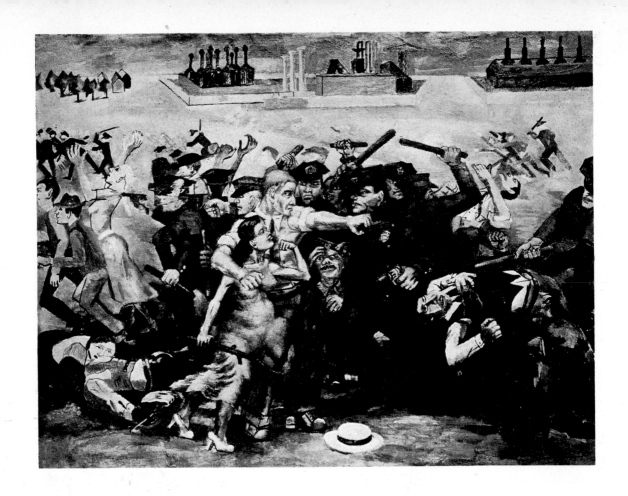

AMERICAN TRAGEDY 1937

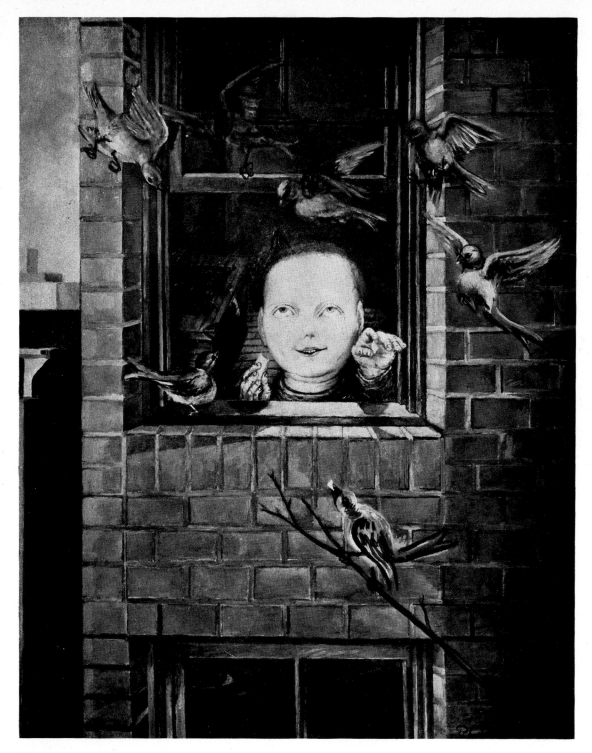

LILY AND THE SPARROWS **1938**
Collection Whitney Museum

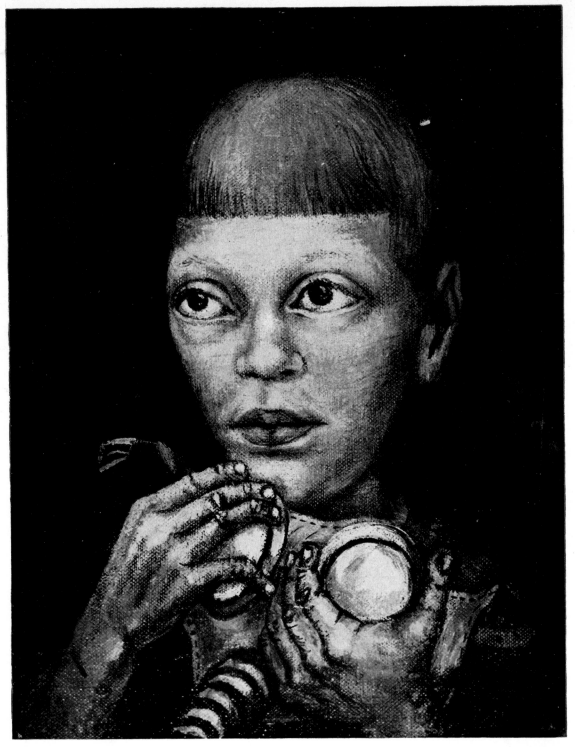

INNOCENTS ABROAD 1938
 Collection Mr. and Mrs. Sol Fishko

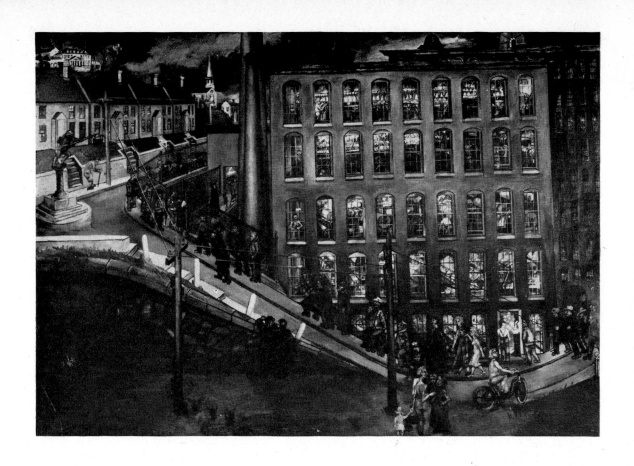

THROUGH THE MILL 1940
 Collection Whitney Museum

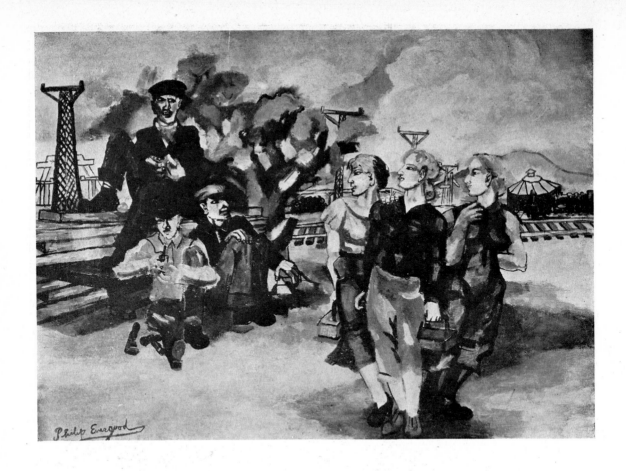

RAILROAD MEN'S WIVES 1933 – 1940
Collection Robert Gwathmey

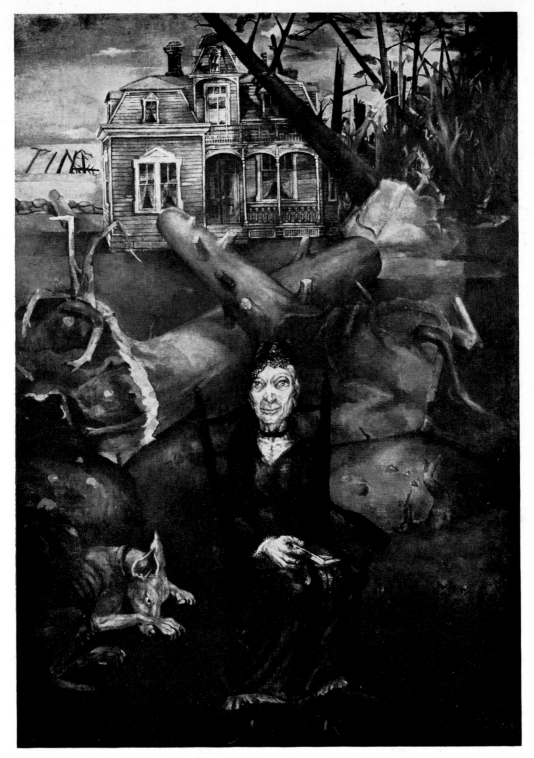

MY FOREBEARS WERE PIONEERS 1940
Collection Mrs. Bruce E. Ryan

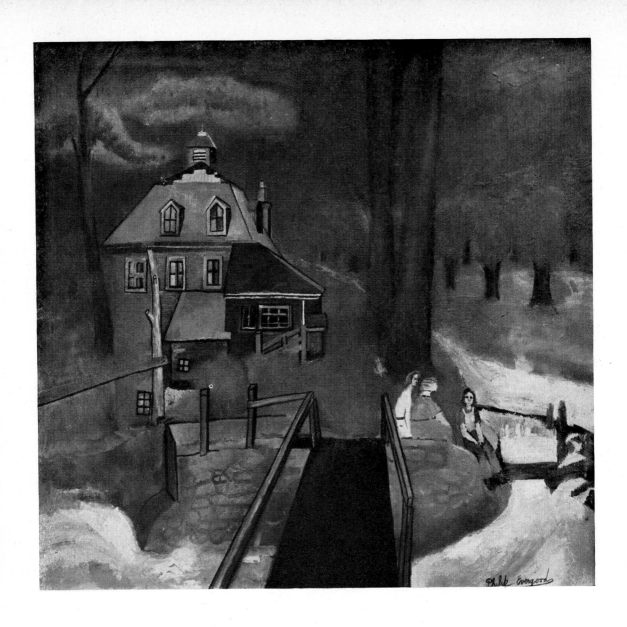

MILLSTREAM
Collection Harry Abrams

1941

52

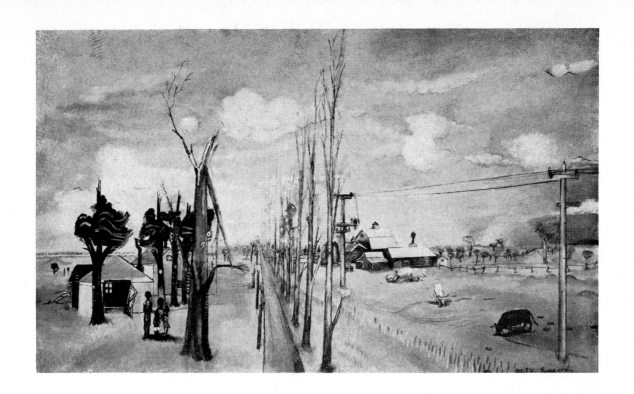

FAT OF THE LAND 1941
 Collection Boston Museum

53

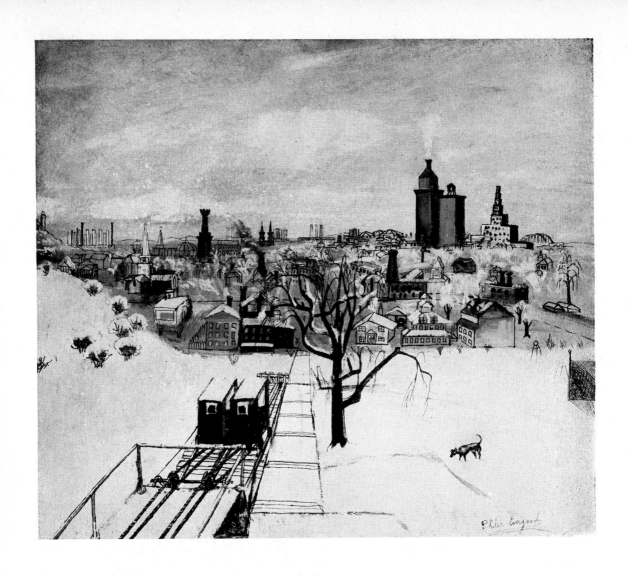

KALAMAZOO IN WINTER 1941
 Collection Metropolitan Museum

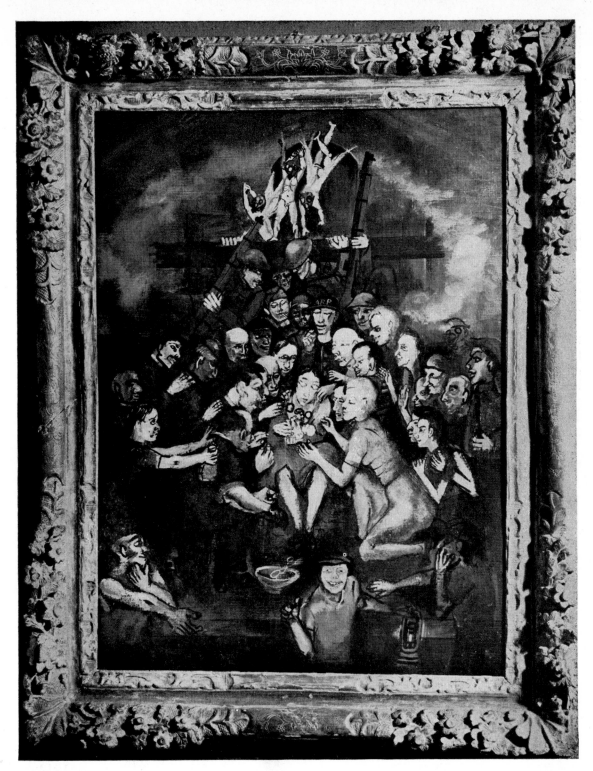

NEW BIRTH 1941
Collection Alfredo Valente

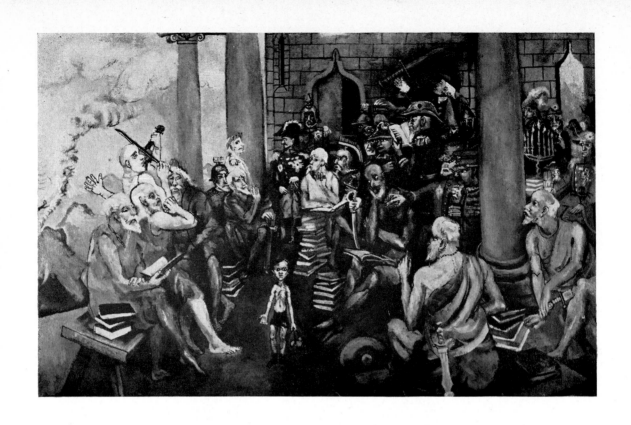

LEAVE IT TO THE EXPERTS 1942
 Collection Arizona State University Museum

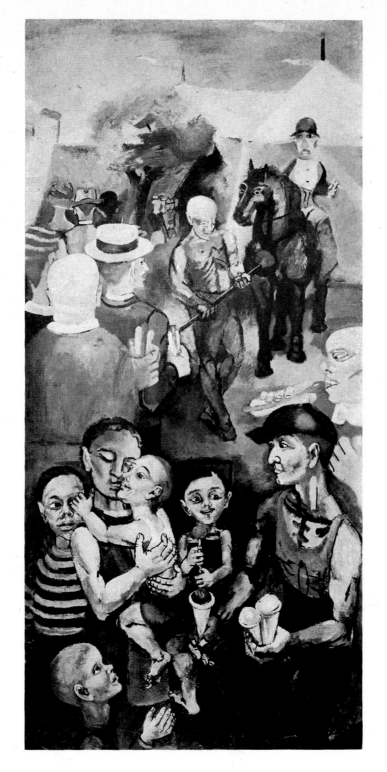

OUTSIDE THE TENT 1942

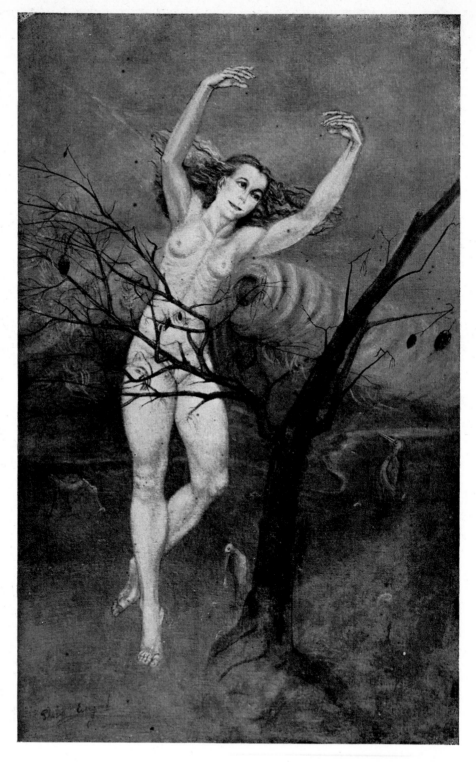

JUJU AS A WAVE 1935 – 1942

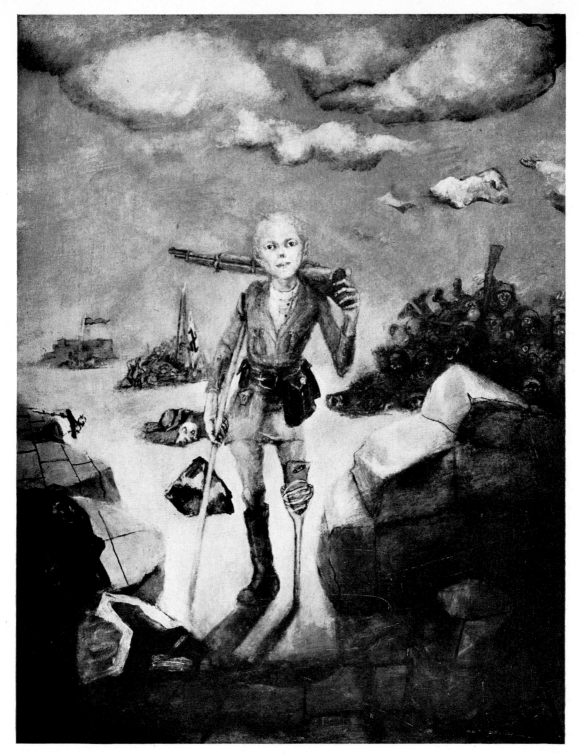

BOY FROM STALINGRAD
Collection John Davies Stamm

1943

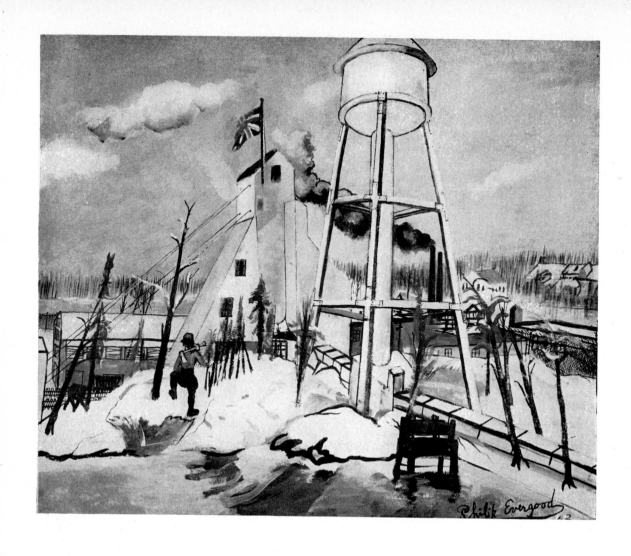

THE PRESTON EAST DOME MINE
Collection Joseph H. Hirshhorn

1944

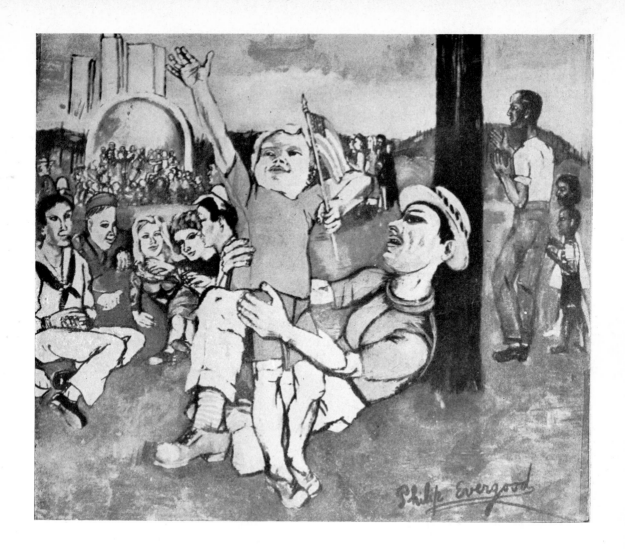

RUSSIAN MUSIC IN CENTRAL PARK 1944
 Collection Emil J. Arnold *

* One in series for Russian War Relief Calendar 1945.

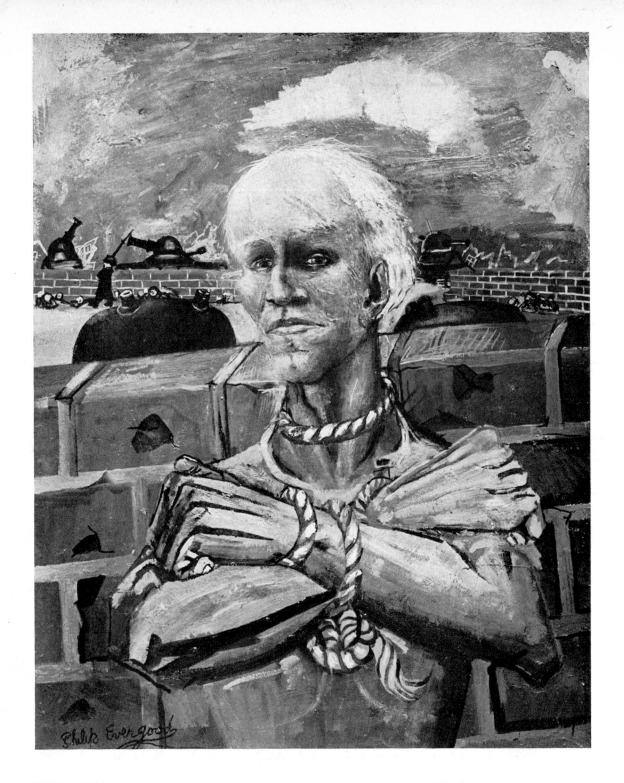

THE HERO 1944

62

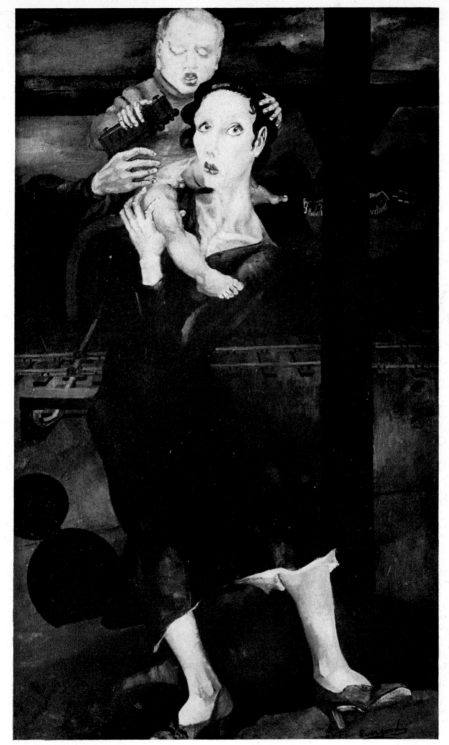

MADONNA OF THE MINES
 Collection Mr. and Mrs. John Kotuk

1932 – 1944

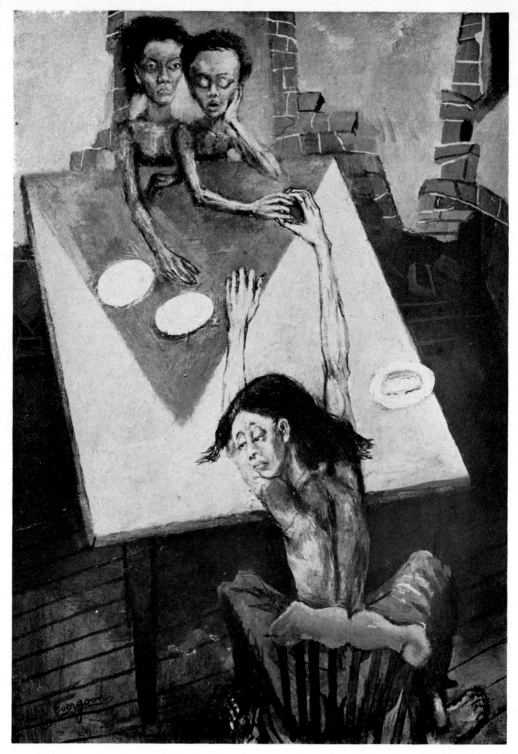

DON'T CRY MOTHER
Collection Museum of Modern Art

1935 – 1944

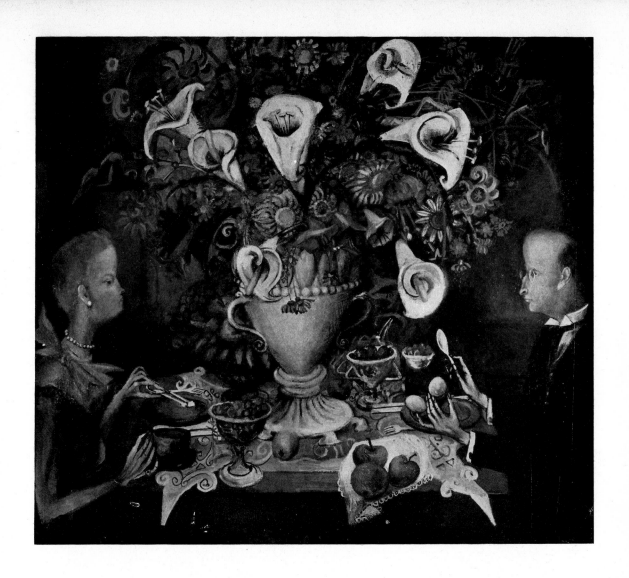

STILL LIFE 1944
 Collection Mrs. Juliana Force

65

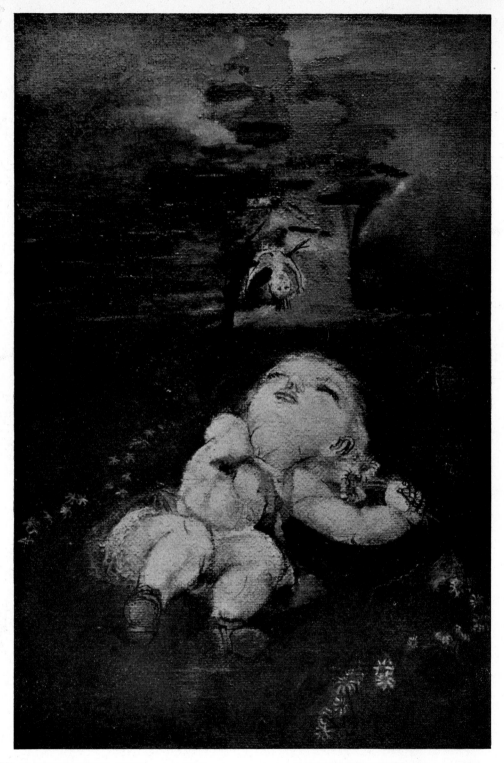

THEY PASSED THIS WAY 1944

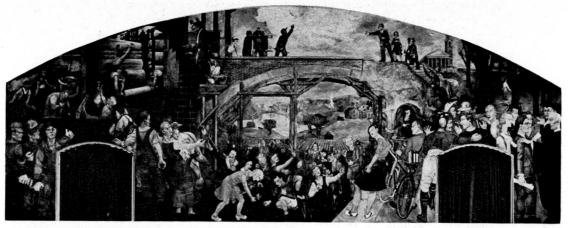

THE BRIDGE OF LIFE 1940 – 1942
 Mural, Kalamazoo College, Michigan

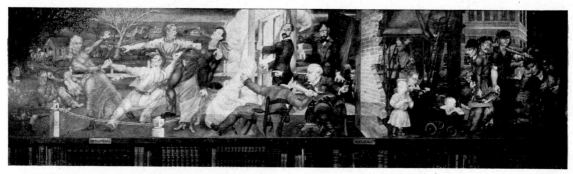

THE STORY OF RICHMOND HILL
 Mural, Public Library at Richmond Hill, Long Island

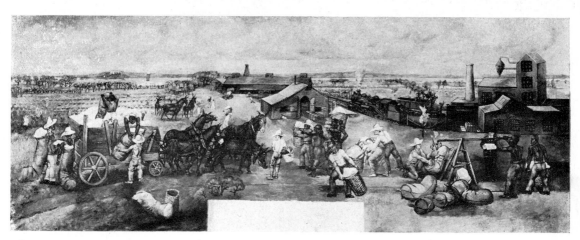

COTTON FROM FIELD TO MILL
 Mural, U. S. Post Office, Jackson, Georgia

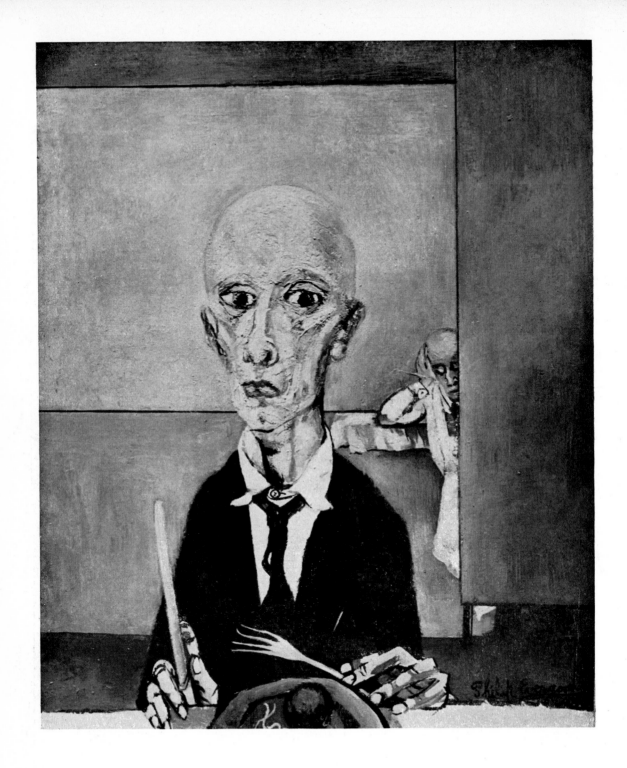

ONE MEAT BALL 1945

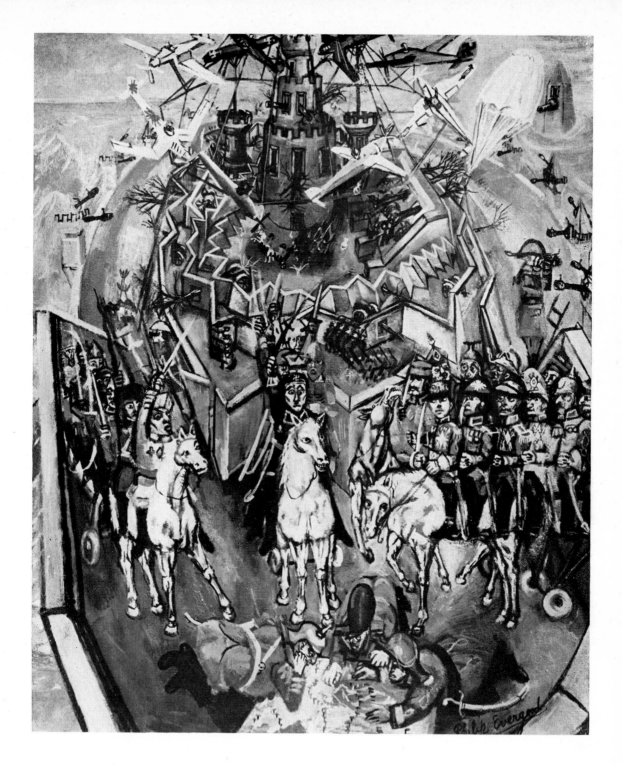

THE QUARANTINED CITADEL
Honorable Mention Carnegie Institute

1945

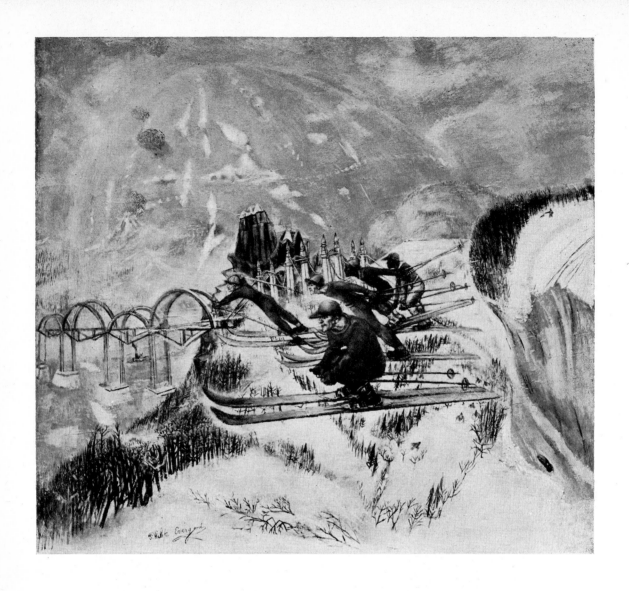

MEN AND MOUNTAIN 1945

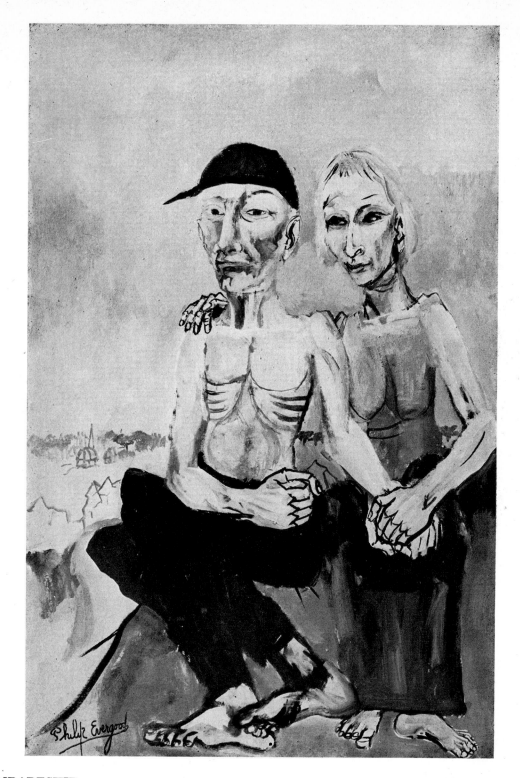

COMRADESHIP 1945

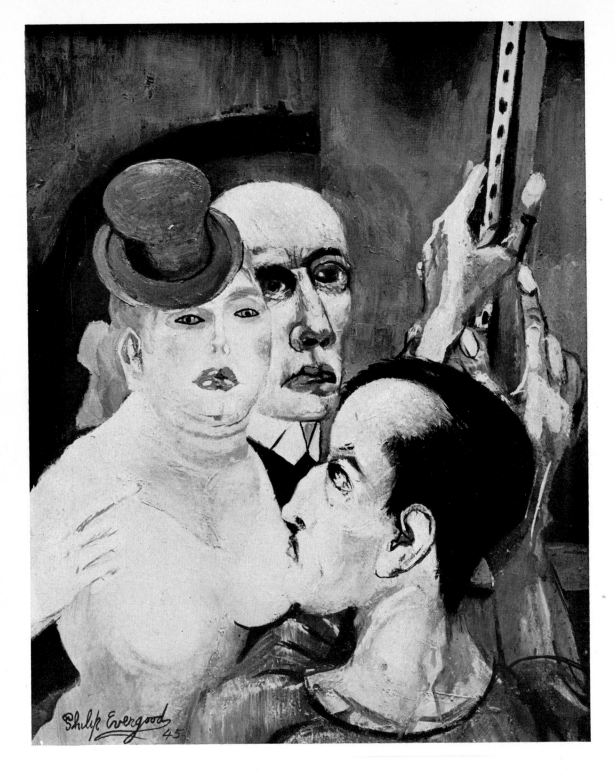

NO SALE 1945

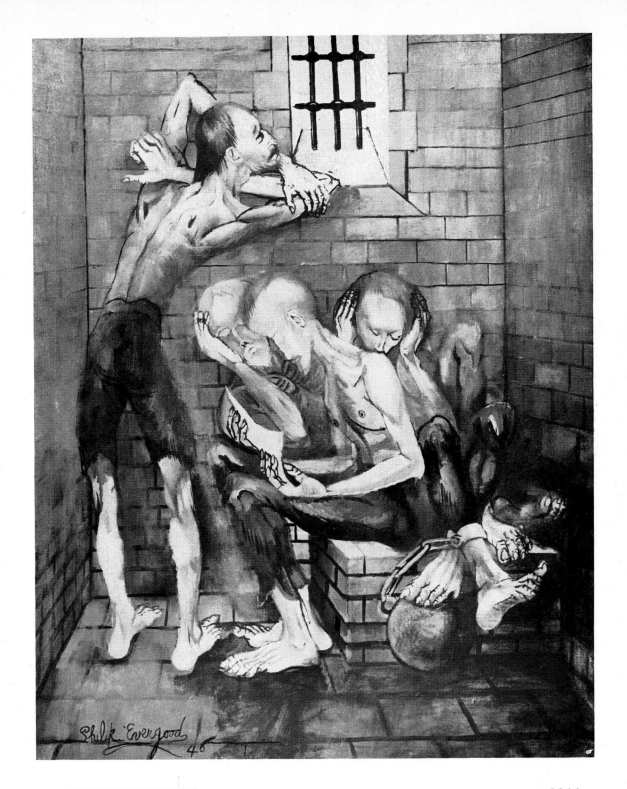

THE INDESTRUCTIBLES 1946

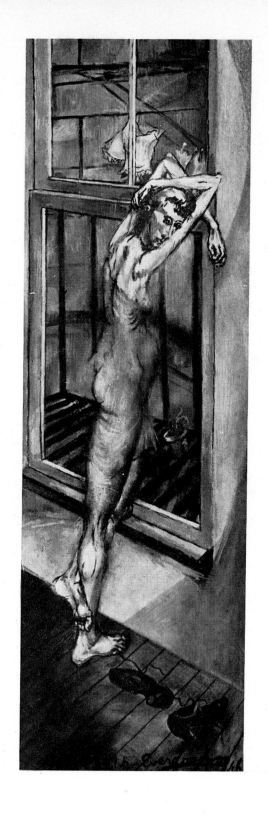

DAWN 1946

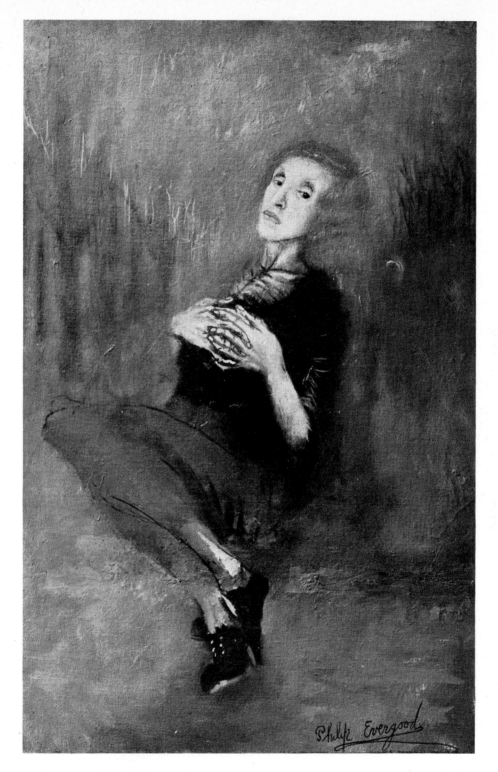

PORTRAIT OF MY MOTHER 1927-1946

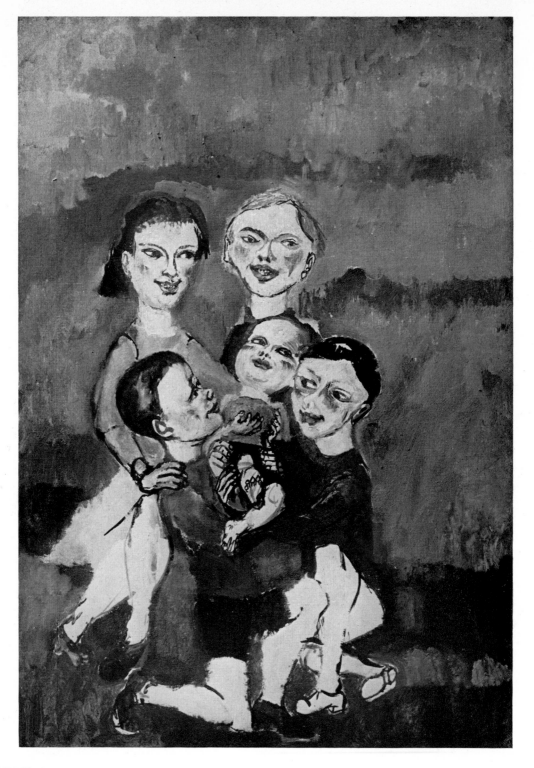

HAPPY CHILDREN 1946

76

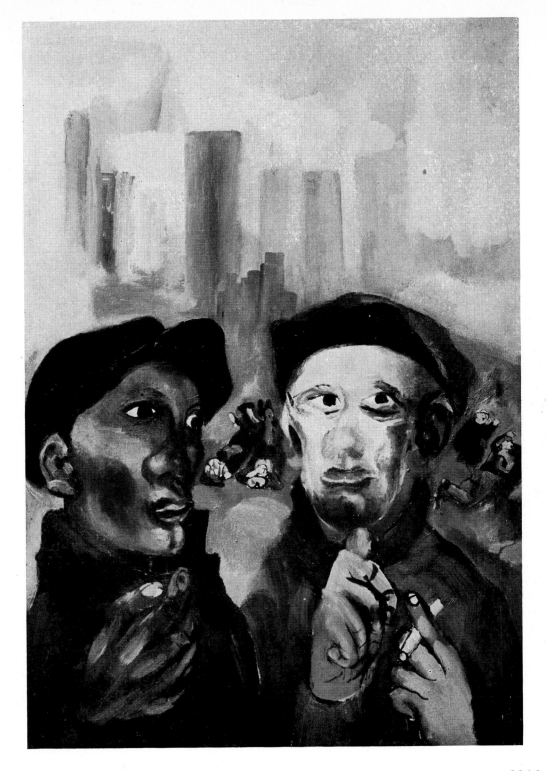

JOBS NOT DIMES 1946

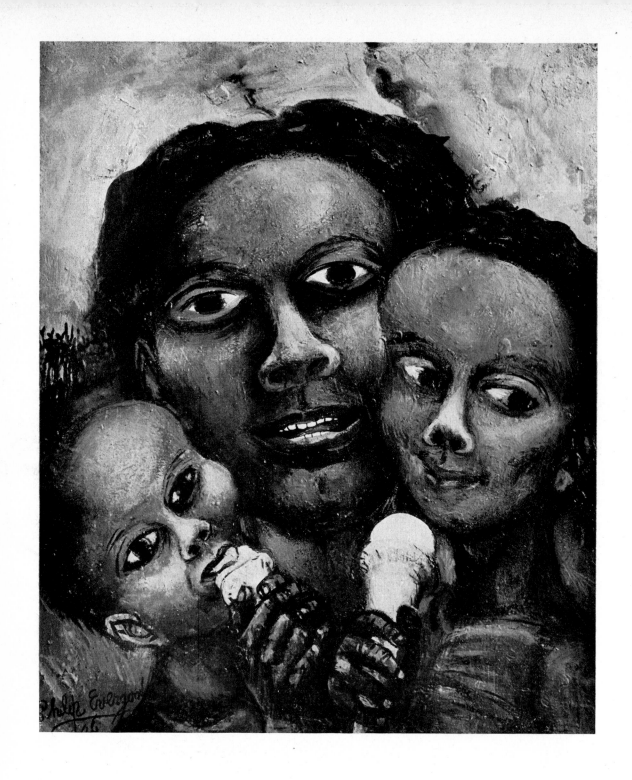

ICE CREAM CONES FOR THREE 1946

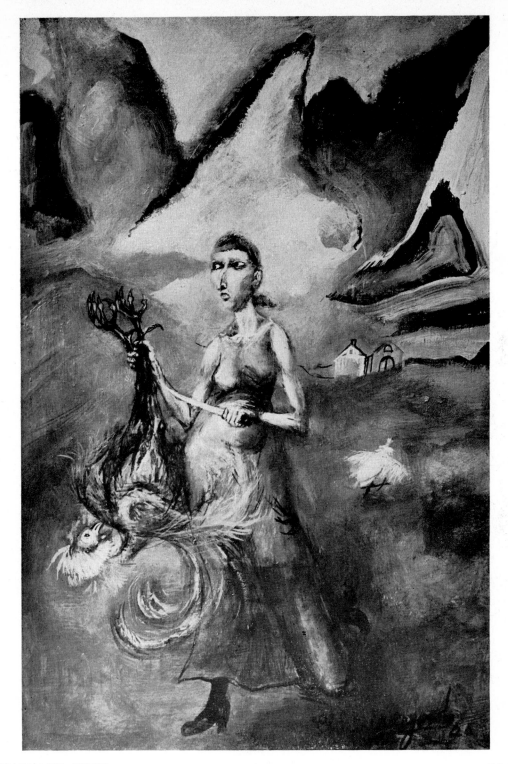

WOMAN AND COCK 1946

79

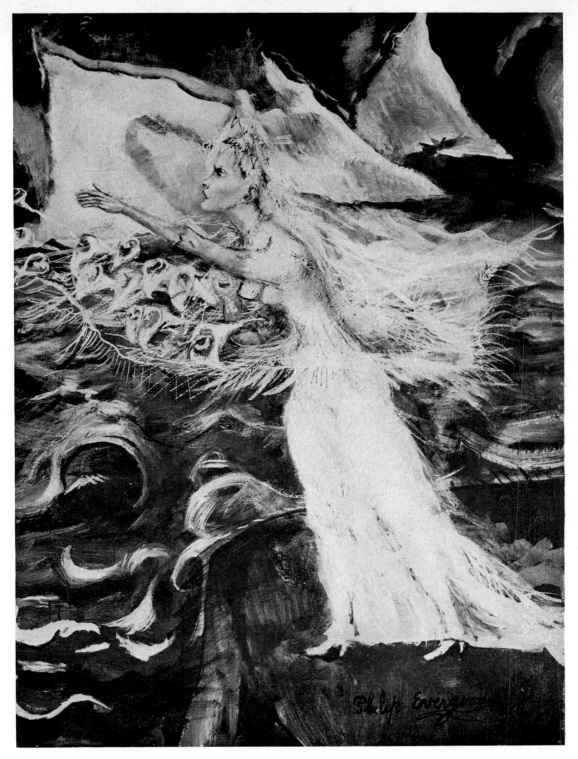

THE BRIDE 1946
 Collection Mr. and Mrs. Marvin Small

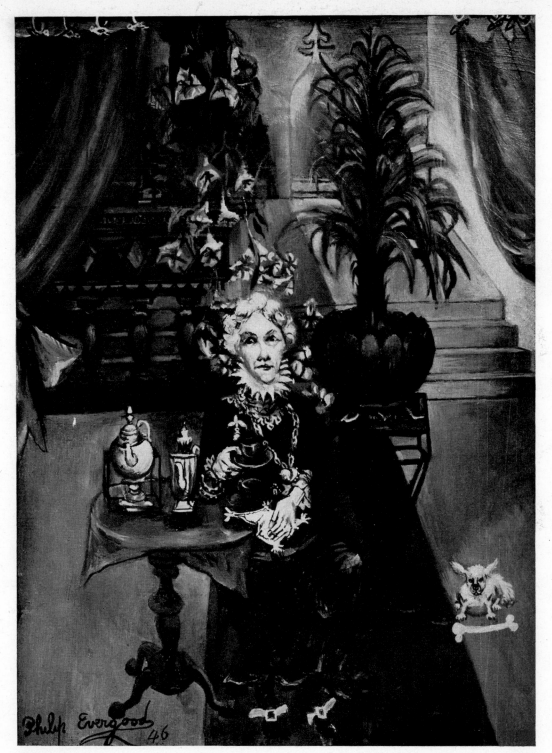

A CUP OF TEA 1946
Collection Lily Harmon

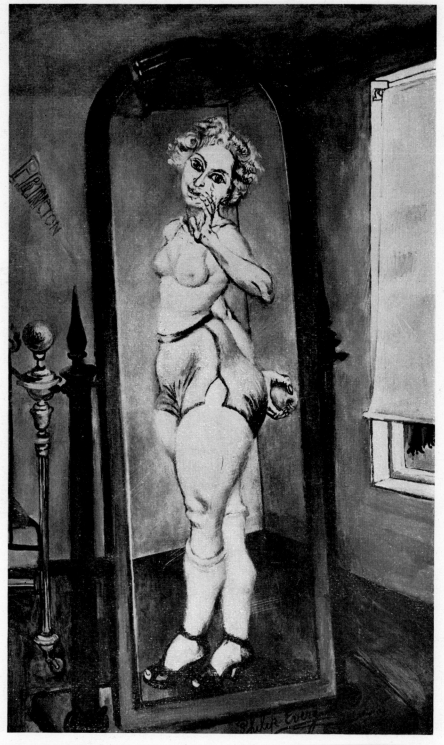

THE HIDDEN APPLE 1946

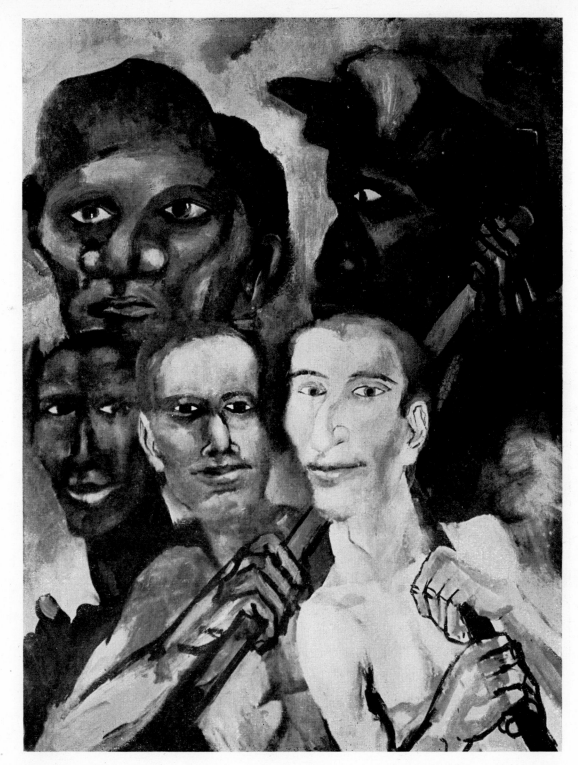

FREEDOM FROM FEAR 1946

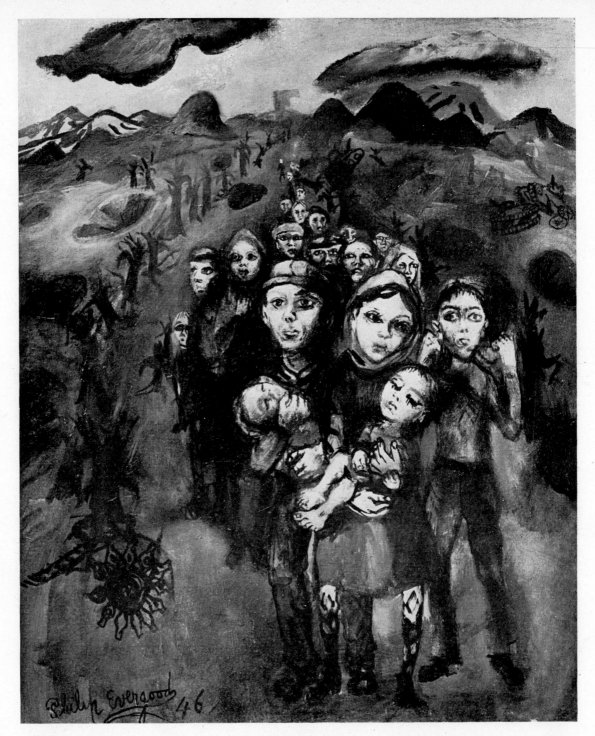

HOME 1946

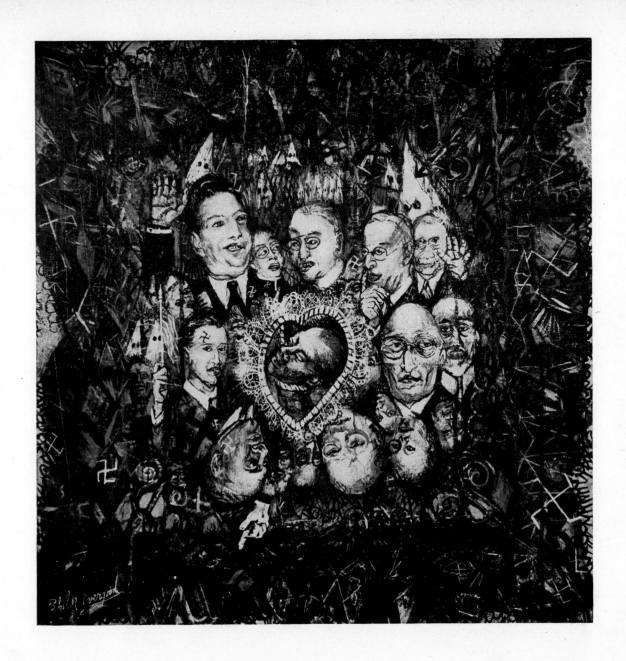

DESIGN FOR A BLACK LACE HANDKERCHIEF 1946

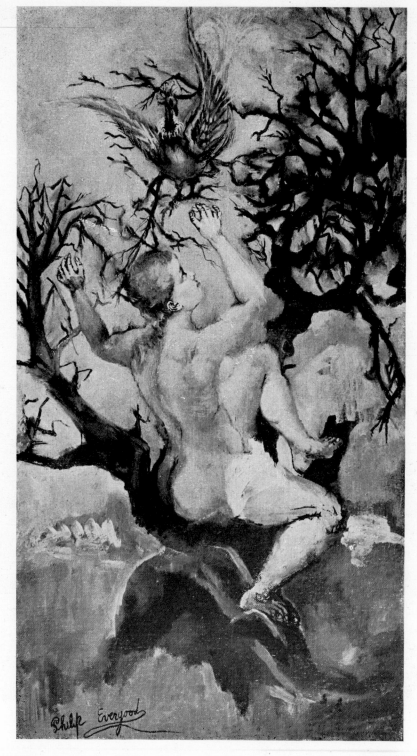

THE BLUEBIRD 1930-46

86

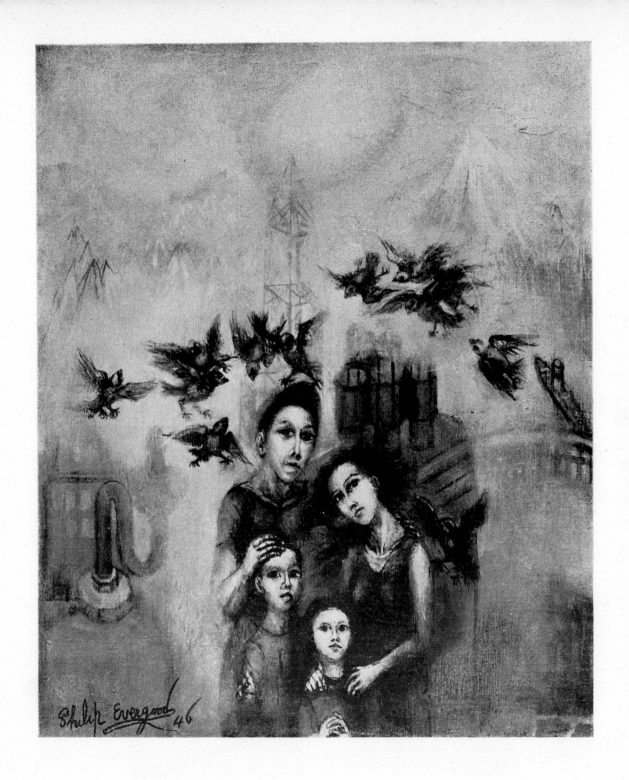

SEEKING A FUTURE 1946

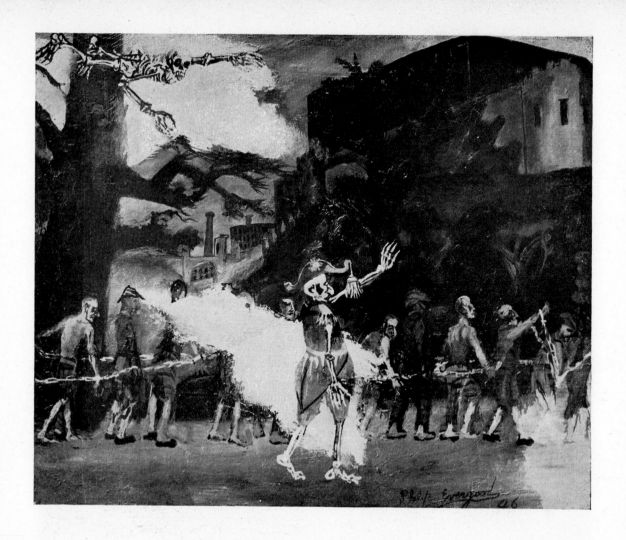

FASCIST FRANCO LEADS 1946

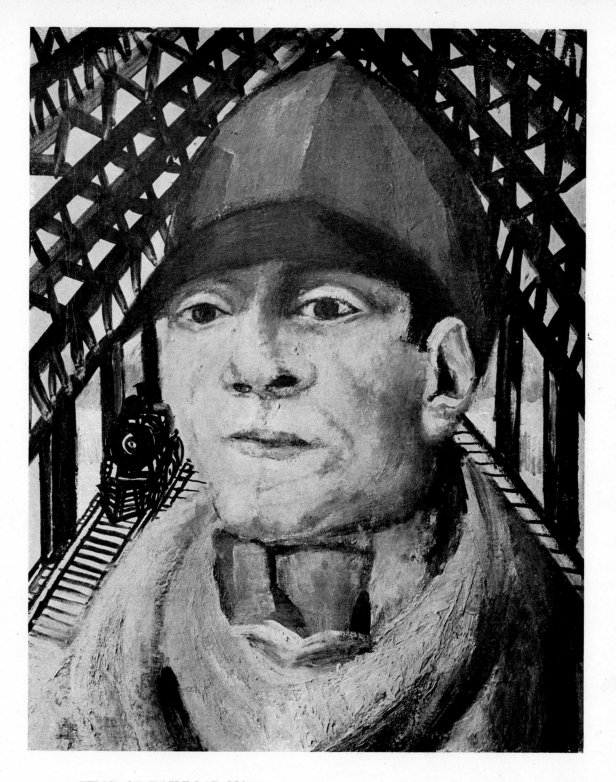

HEAD OF RAILROAD MAN

WORKS IN PUBLIC COLLECTIONS

BOSTON, MASS.
Museum of Fine Arts
1941 *"Fat of the Land"* size app. 28 x 46
(oil and casein on heavy Belgian linen)

BROOKLYN, N. Y.
Brooklyn Museum
1934 *"The Old Wharf"* size 25 x 30
(oil on heavy Russian linen-gesso ground)
gift of John Sloan

CHICAGO, ILL.
Encyclopaedia Britannica Collection
1944 *"Orderly Retreat"* size app. 25 x 40
(oil and casein on canvas)

DENVER, COL.
City Art Museum
1933 *"Burying the Queen of Sheba"* size 25 x 30
(oil on canvas)
gift of Mrs. Philip Cross

GEELONG, VICTORIA, AUSTRALIA
Geelong Gallery of Art
1930 *"Jacob and the Midianites"* size 31½ x 21½
(oil on canvas)

KALAMAZOO, MICH.
Art Institute
1938 *"Little Accomplices"* size 25 x 30
(oil on heavy jute canvas)

LOS ANGELES, CAL.
Los Angeles County Museum of
 History, Science and Art
1931 *"Study of Girl with Cats"* size app. 15 x 20
drawing (pencil and ink brush line)

MELBOURNE, AUSTRALIA
National Gallery of Art
1933 *"Art on the Beach"* size 35 x 53
(oil on heavy Russian linen-gesso ground)

NEW YORK CITY, N. Y.
Metropolitan Museum
1941 *"Kalamazoo in Winter"* size app. 25 x 30
(oil and casein on canvas glued to three ply
wood)

Museum of Modern Art
1944 *"Don't Cry Mother"* size 18 x 26
(oil, casein and varnish glazes on canvas)

	Whitney Museum of American Art	
1938	*"Lily and the Sparrows"*	size app. 25 x 35 (oil and varnish glazes on gesso board)
1940	*"Through the Mill"*	size app. 30 x 45 (oil and varnish glazes on canvas with gesso ground)

	Pepsi-Cola Company Collection	
1944	*"Wheels of Victory"*	size app. 35 x 45 (oil and varnish glazes on canvas)

TUCSON, ARIZONA

Arizona State University Museum

1942	*"Leave it to the Experts"*	size app. 25 x 39¾ (oil and varnish glazes on canvas glued to plywood)

WASHINGTON, D. C.

U. S. Government Collection (Executed under P.W.A.P.)

1933	*"Railroad Men"*	size 30 x 35 (oil and varnish glazes)
1933	*"Spring Shopping"*	size 25 x 35 (oil and varnish glazes)
1933	*"Government Report on North River"*	size app. 6 x 7 feet (oil on canvas)
	Mrs. John C. Clark *"Head of a Boy"*	Collection of Drawings (Pencil)
	James H. Lockhart, Jr. *"Hoboken Life"*	Collection of Drawings and Prints (Litho crayon, ink and violet grease crayon)

PRINTS IN NATIONAL COLLECTIONS

Carnegie Institute

Library of Congress

Brooklyn Museum

Lehigh University, Pa.

Widener Library, Cambridge, Mass.

Grolier Club, New York

PRINTS

E—*Etching*
G—*Engraving* EDITION:
D—*Drypoint*

1	Heaven	E	10	9½x8	1925
2	Centaurs & Men	E	10	7x9¼	1925
3	Abraham & Isaac	E	10	4x5	1925
4	Daughters of Cain	E	10	7⅞x10	1927
5	Little Nude	E & G	10	3½x2½	1928
6	Happy Land	E	20	12x17½	1928
7	Beginning of a Dance	E & G	20	16x9½	1928
8	Introduction to the Dance	E	10	8x10½	1928
9	Primitive Dance	E & G	20	16x9½	1928
10	Rhythm in Nature No. 1	E	20	4½x3½	1928
11	Rhythm in Nature No. 11	E	20	5x4	1928
12	Thoughts about an Ancient Vessel	E, G & D	10	11½x11	1929
13	The Bridge	E	20	5x4	1929
14	Rearing Horse	E & G	20	5¾x3⅞	1929
15	Springtime of Life	D & E	20	6¾x5	1929
16	Classic Tradition	E	20	6½x4½	1929
17	Woodland Reverie	E	20	8x6¼	1929
18	Alone with Nature	E	20	4¼x6¼	1929
19	Death of Absalom	E, G & D	20	13¾x8	1930
20	Menacing Black Horse	E, G	20	15½x5¾	1930
21	Woman & Centaur	E, G & D	20	10x10	1930
22	The Plowman Homeward plods his Weary Way	E	10 / 20	6x4 / 4½x6¼	1930 / 1930
23	Woodland Romance	E	20	7x9¾	1930
24	Adam & Eve No 1	D	20	7x9¾	1930
25	Adam & Eve No. 11	D & G	20	7x9¾	1930
26	Adam & Eve No. 111	D & G	20	10x4½	1930
27	Drawing on a Wall	E, G & D	20	6¼x4½	1930
28	Suffering Woman	E & G	20	4½x6¼	1930
29	Tiger attacking Horse	E & G	20	6¼x8⅜	1930
30	The Sick Horse	E & G	5	7x12	1930
31	The Encroaching City	E	20	7x4⅝	1931
32	Footsteps in the Sand*	E, D & G	30	7½x6½	1936
33	Portrait of a Miner†	(E on steel)	20	9x7	1938
34	Aftermath	E	50	5x7¾	1940
35	City Landscape	E	25	8½x12	1936

** on photographically toned plates*
†(special edition of original prints issued for this catalogue in color)

LITHOGRAPHS

1	Evicted			
2	What Price Glory	15	8x11½	1937
3	Anniversary Party	15	8¾x15	1940
4	City Lights	200	12x8½	1941
5	Still Life†	200	16x11¼	1944

** (litho. on zinc plate executed for Kalamazoo Art Institute)*
† (edition of 200 executed for A.C.A. Gallery Kalamazoo, Mich.)

MURALS

"The Story of Richmond Hill"
Public Library, Richmond Hill, L. I.
(Executed on WPA Art Project) — Oil on Cotton canvas primed with gesso — 27' x 6' — 1936-38

"Cotton from Field to Mill"
U. S. Post Office, Jackson, Ga.
(Executed for the Section of
Fine Arts—U. S. Treasury Dept.) — Oil and Casein on Russian Linen — 15' x 4½' — 1938

"The Bridge to Life"
Welles Hall, Kalamazoo College,
Michigan
(Building designed by Aymar Embury, II)
Executed under Carnegie Corp. Grant — Oil and Casein on heavy Belgian linen — 40' x 16' (*arc shaped*) — 1940-42

ILLUSTRATIONS

Milton's Lycidas
With four original etchings
88 copies—Limited Edition
Harry Lorin Binsse—New York — 1929

Russian War Relief
Calendar for 1945
12 Colorplates
Original Paintings collection of: E. J. Arnold

Vol. XXVII, No. 6 — Fortune Magazine—
Expansion in CO^2
Walter Kidde Co.

Vol. XXXII, No. 5 — Fortune Magazine— — June, 1943
Will Clayton's Cotton: I

Vol. XXXII, No. 6 — Fortune Magazine— November, 1945
Will Clayton's Cotton: II — December, 1945

Australia
Container Corporation
Advertisement

Time Magazine— — February 1946

Fortune Magazine— — March 1946

ONE-MAN EXHIBITIONS

Dudensing Exhibition, 11 E. 57th St., N. Y.	Nov. 12, 1927
N. E. Montross Gallery, 26 E. 56th St., N. Y.	Dec. 31, 1929
Balzac Galleries, 449 Park Ave., N. Y.	Dec. 7, 1931
Montross Gallery, 785 Fifth Avenue, N. Y.	Mar. 13, 1933
Montross Gallery, 785 Fifth Avenue, N. Y.	Jan. 21, 1935
Hollins College, Virginia (*drawings*)	1935
The Denver Art Museum, Denver, Col.	Mar. 1936
Athenaeum Gallery, Melbourne, Australia	July 10, 1937
A. C. A. Gallery, 52 West 8th St., N. Y.	Feb. 20, 1938
A. C. A. Gallery, 52 West 8th St., N. Y.	Mar. 1940
McDonald Gallery, 665 Fifth Avenue, N. Y. (*drawings*)	Apr. 19, 1941
Kalamazoo Art Institute, Kalamazoo, Mich.	Jan. 1941
A. C. A. Gallery, 26 West 8th St., N. Y.	Oct. 1942
A. C. A. Gallery, 63 East 57th St., N. Y.	Mar. 1944

AWARDS

The M. V. Kohnstamm Prize—$250.00—Oct. 24, 1935
from Art Institute of Chicago for picture *Evening Reading*

Purchase Prize Artists for Victory Exhibition—$500. —1942
from Metropolitan Museum for picture *Kalamazoo in Winter*

Portrait of America—Pepsi-Cola—$2,000—July 1944
Second Prize—for picture *Wheels of Victory*

Carnegie Institute—$300—Second Honorable Mention
Oct. 1945 for picture *The Quarantined Citadel*

chronology

born	October 26, 1901 in an artist's studio at 118 West 23rd Street, New York City.
father	Miles Evergood, landscape painter. Born in Australia under the name of Evergood Blashki. Ancestors originally came from the Russian-Polish border.
mother	Flora Jane Perry. Born in England, of Cornish-Irish descent. Studied art and music in Paris, Vienna and Munich.
age 3	Started to study piano under a gifted teacher, Madame Rabagliatti.
age 6	Attended Ethical Culture School. Played in his teacher's concert at Carnegie Hall, New York.

In these early years summers were spent with his father and mother in the countryside of New England and the islands off the East Coast, from Newfoundland to Maine, where his father painted landscapes.

Started to draw and paint at this time. During all these years his mother's greatest friend was Louise Fitzpatrick, only student of Albert Ryder. The association of the family with the great painter was on a very close and intimate basis.

age 8-12	Taken to England by his mother to be educated under the sponsorship of English relatives.

Sent to a boarding school in a small south coast town in Sussex. Remained one year. Attempted to escape. Sent to another boarding school in Essex. Spent an unhappy year there.

Sent to another boarding school which specialized in preparing boys for the Royal Navy.

age 13	Beginning of World War I. Took entrance exam into Royal Naval Training College of Osborne.

Later rejected under new age ruling.

Hospitalized with peritonitis, caused by a ruptured appendix. Invalided for several months during which time passed competitive exam into Eton College, Windsor.

age 14-18	Attended Eton College, where Latin, the classics, the Bible were studied. Spare time drawing and writing poetry, which was encouraged by his Housemaster. Also participated in athletics representing the school on the first teams in boxing and shooting. Also participated in football, rowing and running.

During part of these war years, vacations spent in London with mother, who was visiting England, his father being on active duty with Army Medical Corps. On several of these occasions air raids were suffered in attacks by

Zeppelins and planes. At these times mother and son would sleep at opposite ends of apartment fearing for the father's sake the loss of both lives should a bomb land.

During last year at Eton participated in intensive O. T. C. training for military service and at end of war went to Brussels for special course of study in French and Latin.

age 19

Passed entrance exam into Cambridge University—Trinity Hall College. Took English course intending later to go in for law or into civil engineering under the auspices of his uncle George Stephens Perry, M. Inst. C. E., who was Chief of Operations in heightening the Assuan Dam on the Nile, which at that time was the largest dam project in the world.

age 20-22

Interest in academic studies rapidly dwindled.

Desire for art brought suddenly into sharp focus. Sympathetically supported in decision to go in for art by Henry Bond, Head of Trinity Hall College.

Left Cambridge.

In London visited Havard Thomas, sculptor with drawings. Encouraged and assisted by him to take up art as a profession.

Accepted by Henry Tonks for Slade School.

Worked at sculpture and drawing helping to support self by working as sculptor's assistant, and for a time acted as sparring partner for professional boxers in training.

Returned to America.

One year with Luks at Art Students League, working at Educational Alliance Art School nights. Started to paint in oil for the first time.

age 23

Trip to Belgium with Melville Chater, writer, for National Geographic Magazine visiting Ghent, Bruges, Antwerp, etc., etc., and studying great works of art in each place. Then to Paris.

After working in Julian's Academy under Laurens and for a short period with L'Hote retired to room in rue du Cherche-Midi and worked alone for one year.

Met some of the French painters including Utrillo.

Made the acquaintance of Julia Cross who was studying painting in Paris and Barbizon.

Exhibited Salon d'Automne, Paris

age 24	Continued to paint alone. Imaginative biblical subjects.
	Visited Italy seeing many of the important works throughout the country.
	Worked in southern France for several months.
age 25	Continued work alone experimenting in different mediums.
	Supported self doing carpentry work and odd jobs aided by small contributions from home.
	Returned to America to be near ailing mother.
age 26	Loaned studio at Martinsville, N. J. by Harvey O'Higgins, author.
	Worked there one year benefiting greatly by contact with nature. Visiting his mother weekly, who died in New York a few months before his ——— First one-man exhibition at Dudensing Gallery, 11 East 57th Street, N. Y. Fifty-three paintings exhibited and one piece of sculpture. Several small pictures sold. Became interested in the technique of etching through meeting Phil Reisman who had a press. Learned from him the fundamentals of the craft.
	Met N. E. Montross who became interested in his work.
age 27-28	Continued work in Martinsville and New York.
	One-man exhibition at N. E. Montross Gallery, East 56th Street, New York.
	Fifteen etchings shown along with twenty paintings.
	Returned to France.
	Continued work in a studio on rue Delambre.
age 29	Continued painting imaginative pictures.
	Worked for a short time with William Hayter, learning something about the technique of engraving.
	Again met Julia Cross who then was studying ballet under Alexandre Volinine.
age 30	Visited Spain for six months. Wandered around continuing to paint. Studied the works of El Greco, Goya, Velasquez. Lived four months in Toledo in rooms overlooking Greco's Garden. Paris to work for several months. Rejoined and married Julia Cross in New York. Tried to solve housing and financial problems. Moved four times in first year. Took half time job. Julia did likewise. Painted afternoons and nights. Small one-man show Balzac Galleries, 449 Park Avenue, N. Y.

age 31 Living in a loft on Fourteenth Street. Working part time.

Participated in Exhibition of Murals by American Painters and Photographers at the Museum of Modern Art. Title of mural was ironically "Towards Peace".

During the exhibition met for the first time some of the younger contemporary painters participating in it—Shahn, Gellert, Marsh and Poor, etc.

About this time began to search for expression in contemporary life and scene. Lost interest in subjects purely drawn from the imagination.

Moved to 49 Seventh Avenue. Painted the enactment of a scene from life at that address "Burying the Queen of Sheba" (see reproduction).

age 32 One-man show Montross Gallery (at this time moved to Fifth Avenue). Thirty-one oils shown. Many canvases of contemporary scene though imaginative in concept. First sale of importance—"Concert by the El". Sold to a Philadelphia collector.

Began to become interested in the artist's role in society—social protest art—potential importance of the artist as a propagandist.

Attended John Reed Club forums and exhibited work there—including "Mine Disaster" (see reproduction).

Painted large picture "Music" (reproduction see also this catalogue) for the Pierre Degeyter Club which paralleled the John Reed in music circles.

age 33 Employed by the U. S. Government on Public Works of Art Project. Produced three pictures for same (see pictures owned by U. S. Government).

Joined other artists seeking enlargement and broadening of this Project.

Artists Committee of Action. Beginnings of Artists Union.

age 34 First exhibited Whitney Museum Biennial ("Art on the Beach"). Continued painting contemporary scene.

One-man exhibition Montross Gallery (39 canvases).

Withdrew picture "Sunday in Astoria" from Municipal Art Committee Exhibition at Hearns Store along with other artists in protest over inadequate representation of artists on Municipal Art Committee.

Active work in Artists Union.

Participated in exhibition "Struggle for Negro Rights" A. C. A. Gallery, 52 West 8th Street.

Exhibited with Uptown Gallery group (West 72nd Street) and Society of Independent Artists.

Exhibited first time Chicago Art Institute. Awarded M. V. Kohnstamm prize for "Evening Reading" (controversial issue in press).

Joined Midtown Gallery group.

Moved to Woodside, Long Island.

Enrolled in Mural Section, W.P.A. Work on mural Public Library, Richmond Hill, L. I.

Elected to An American Group.

Joined American Society of Painters, Sculptors and Gravers which was fighting for Rentals on pictures exhibited in museums.

age 35 Signed the call for the American Artists Congress.

Continued work in Artists Union which was concerning itself with protecting the interests of artists on W.P.A.

One-man show Denver Art Museum.

Continued work on Richmond Hill Mural working on scaffold in library. Elected to Executive Board, Artists Union.

Joined faculty of American Artists School, 131 West 14th Street, painting and composition (worked in spare time as donation).

Participated in first exhibition of U. S. Artists in support of Spanish Loyalist cause at A.C.A. Gallery.

Participated in the famous "219 Sit-in Strike" at headquarters of W.P.A. Art Project in protest over layoff of fellow workers.

age 36 Joined the A.C.A. Gallery and started to exhibit regularly there.

Continued work in Artists Union—elected President of same.

Also was representative of A. U. on Coordination Committee and was a delegate on many Grievance Committee meetings with officials of W.P.A. projects such as the one when a raise in pay for artists was won.

Elected to Executive Board of Artists Congress.

Mural at Richmond Hill Library unveiled.

Painted mural "Cotton" for U. S. Post Office at Jackson, Ga.

Attended national job march to Washington in support of unemployed workers. One-man exhibition at Athenaeum Gallery, Melbourne, Australia arranged by his father, which became a storm center of controversy between modern and conservative art groups. Picture "Art on the Beach" purchased by Public

100

donations at exhibition (collection inaugurated by groups of modern painters) and presented to National Gallery, Melbourne.

Spoke as representative of Artists Union at American Artists Congress, Second Annual Convention, at Carnegie Hall, on "Government Support of Art," and also at mass meeting when Artists Union received its charter as a member of the CIO.

age 37

First one-man show at A.C.A. Gallery (22 oils exhibited). Many social-protest pictures exhibited and several imaginative satirical ones.

Mural "The Story of Richmond Hill" at Public Library, Richmond Hill, L. I., picketed by local civil groups led by D.A.R. and Republican Club ladies, protesting its existence on ground that the "figures have foreign racial characteristics and are therefore un-American; also the human forms are too clearly delineated—therefore indecent."

Local workers, Artists Union, Mural Society and other art groups, as well as the Art Commission of the City of N. Y. headed by Ernest Peixotto support mural and win fight for its retention.

Participated in show at A.C.A. dedicated to the New Deal. First time represented in Carnegie International at Pittsburgh with picture "Street Corner". Continued to paint, teach and write articles on art for such publications as: Art Front and Direction Magazine.

age 38

Accepted full-time post of managing supervisor, Easel Division of the New York W.P.A. Art Project where continued to support and fight for freedom of expression for the artist and high esthetic quality of art produced on the Project. Painted at night.

Death of his father at Kalorama, Victoria, Australia and Memorial Exhibition of his work in Melbourne.

Served on Jury for Contemporary Exhibition at New York World's Fair, and exhibited "My Forebears were Pioneers" in that show.

Participated in World of Today Exhibition arranged by Elizabeth McCausland at Berkshire Museum, Pittsfield, Mass.

age 39

Second one-man show at A.C.A. Gallery (24 pictures including "American Tragedy", "Lily and the Sparrows" and "My Forebears Were Pioneers" (see reproductions).

Represented in "Survey of American Painting" at Carnegie Institute with "Through the Mill" (see reproduction). Accepted post as Resident Artist, Kalamazoo College, Michigan, under Carnegie Corporation Grant. Started painting large mural in College, taking students into factories and industries, involving them in the plans and creative process of a large work of art.

Continued with easel painting and taught two nights per week at Kalamazoo Art Institute.

age 40-41 Continued work on mural completing over half the work. Came East on vacation and was stricken with grave illness involving two very serious intestinal operations. After hanging between life and death for six weeks the discovery by X-ray of a surgical sponge within the peritoneal cavity necessitated a third operation and several weeks more on the critical list of the hospital. After two months convalescence returned to the scaffold of Kalamazoo College and finished mural "The Bridge To Life" in six months.

Returned East and continued painting.

Joined Artists League of America.

Third one-man exhibition at A.C.A. Gallery (now located at 26 West 8th Street) 33 pictures exhibited; 9 pictures sold.

Purchase Prize, Metropolitan Museum, Artists for Victory Exhibition.

age 42 Taught art in temporary capacity at Muhlenberg College, Allentown, Pa., one day per week, substituting for Head of Art Department, George Rickey, who went into Army. Also taught private class organized at Bethlehem, Pa., and another at the Settlement Music School, in Philadelphia. Gave up these jobs to accept War Department invitation to go over seas with the U. S. Armed Forces and "Record the impact of battle" along with other contemporary artists, including Gropper and Refregier. After signing Government contracts and making extensive preparations to leave over a period of three months, undergoing inoculations for several likely diseases, rejected on the grounds of being "unacceptable to accompany the Armed Forces of the U. S." Investigation on the part of the artist showed that he was still acceptable as an artist for the quality of his work but that he had joined the fight against Fascism at too early a date. Took an 8-hour a day job with the Midtown Frame Shop, mitering and joining frames. Worked there several months, painting at night.

age 43 Joined Independent Voters Committee to work for re-election of President Roosevelt.

Fourth one-man exhibition A.C.A. Gallery, newly located 61 East 57th Street (25 pictures—11 sold).

Second Prize Pepsi-Cola "Portrait of America" Exhibition. Taught for a few months at State County and Municipal Workers Union, CIO, New York along with Frank Kleinholz who organized this art class.

Part of summer spent painting illustrations for Russian War Relief Calendar of 1945.

age 44 Moved from Woodside into the City again.

Flew down to Houston, Texas on cotton article for Fortune Magazine.

Awarded Second Honorable Mention, Carnegie Institute for painting "The Quarantined Citadel".

Continues to paint.

WRITINGS
by Philip Evergood

ART FRONT *"Question and Answer"—Federal Art Project* Feb. 1937

ART FRONT *"Building a New Art School"* 1937

THE ART DIGEST *Response to "Coffee-Pepper Bill"* Mar. 1, 1938
 (quoted by Peyton Boswell)

DIRECTION *"Should the Nation Support its Art?"* Apr. 1938

FOREWORD TO A.C.A. GROUP SHOW Sept. 11, 1938

NEW MASSES *Article on William Gropper* Feb. 29, 1944

DAILY WORKER *"Should Art Prettify Heroes?"* Nov. 2, 1942

DAILY WORKER *"Soviet Posters"* Sept. 25, 1943

FOREWORD TO
CATALOGUE OF THE MEXICAN ARTIST, *Conrado Vasquez* May 5, 1944

FOREWORD TO
CATALOGUE OF WILLIAM GROPPER'S EXHIBITION 1944

NEW MASSES *"Why I Vote for F. D. Roosevelt"* Oct. 10, 1944

DAILY WORKER *Article on work of David Burliuk* Dec. 22, 1944

NEW MASSES *Letter to Editor on "Surrealism"* Jan. 23, 1945

DAILY WORKER *Letter replying to E.S.T. on "American Art Situation"*
 Jan. 12, 1945

NEW MASSES *"Social Surrealism"* Feb. 13, 1945

DAILY WORKER *Article on the work of Anton Refregier* .. Mar. 18, 1945

NEW MASSES *Critiial Analysis of Albright Brothers Exhibition* Nov. 1945

MAGAZINE OF ART *"Sure I'm a Social Painter"* Nov. 1943

TALKS, LECTURES
and RADIO BROADCASTS
by Philip Evergood

TALK at Artists Union Mural Craft Meeting on
"The Crisis on the Mural Project" — June 21, 1937

SPEECH at Carnegie Hall on
"Government Support of Art" for American Artists Congress — Dec. 17, 1937

LECTURE at Museum of Modern Art
A Symposium on
"Art for the Subways" — Mar. 2, 1938

LECTURE at Flushing W.P.A. Art Project Headquarters
"Murals under W.P.A." — 1938

LECTURE at Harlem Art Center on
"Contemporary Easel Painting in America" — Apr. 1, 1938

LECTURE at Springfield Museum of Fine Arts
in support of Federal Art's Bill — Mar. 23, 1938

RADIO PROGRAM—W.Q.X.R.
"Art in a Democracy"—with Peggy Bacon — Apr. 29, 1938

SPEECH at Public School No. 11
for United American Artists Mass Rally — May 18, 1938

SYMPOSIUM—American Artists Congress
Museum of Modern Art
with Schmidt, Cahill, Davis, Mechau — May 6, 1938

SYMPOSIUM—W.N.Y.C.
"Social Art"
with Gropper, Eliz. Olds — Sept. 23, 1938

LECTURE at Brooklyn Museum
"The Role of the Contemporary Painter" — Oct. 29, 1938

LECTURE at Columbia University—Art Class
"History of Mural Painting" — 1939

LECTURE at American Artists School
"Social Content in Art" — Apr. 2, 1939

RADIO PROGRAM—W.A.B.C.
"Living Art" — Dec. 8, 1942

RADIO PROGRAM—W.N.Y.C.
"Art in New York" with Frank Kleinholz Dec. 4, 1944

PAPER READ to Students of Smith College
Summer Art Course
Fundamentals, Functions, Frameworks of Art Aug., 1944

LECTURE at Art Alliance, Bethlehem, Pa.
"The Artist is a Human Being" 1944

SYMPOSIUM—A.L.A.
"Artists Information Please"
with McCausland, Gwathmey, Kleinholz, Segy Feb. 18, 1944

LECTURE at Lehigh Valley Art Alliance,
Y.M.C.A., Allentown, Pa.
"Modern Technique in Painting" 1944

LECTURE at Museum of the City of N. Y.
to N. Y. School Children under auspices of School Art League on
"The Artist in Society" Oct. 1944

RADIO PROGRAM—W.N.Y.C.
The School Art League
"Meet the Artist" Oct. 21, 1944

LECTURE at The Educational Alliance
"Social Realism in Art" Feb. 15, 1945

LECTURE at Y.M.H.A. auspices of the A.L.A.
"Social and Abstract Art"
with Gwathmey, Nat Wermer and Pereira March 1945

RADIO PROGRAM—W.L.I.B.—Brooklyn, N. Y.
"The San Francisco Conference"
Its significance for an American Artist May 2, 1945

LECTURE at A.C.A. Gallery
"The Last Ten Years in American Art"
with Kleinholz, Jack Levine, Gwathmey and Larkin Dec. 21, 1945

LECTURE at School for Art Studies, N. Y.
"Art that Lives" Jan. 9, 1945

BIBLIOGRAPHY

catalogues, books and special articles

MURALS BY AMERICAN PAINTERS AND PHOTOGRAPHERS
Catalogue, Museum of Modern Art, 1932

"THE GIST OF ART" by John Sloan, 1939
Published by American Artists Group—*page 42*

CATALOGUE OF AN EXHIBITION OF 100 PRINTS AND DRAWINGS
From the collection of James H. Lockhart, Jr.,
at Carnegie Institute, Pittsburgh. Pa.
Introduction by Robert McDonald—*pages 210 and 211*

FIFTY AMERICAN PRINTS
Published by the American Institute of
Graphic Arts, 1938—*page 21*

ART IN PROGRESS
A survey prepared for the Fifteenth Anniversary of the
Museum of Modern Art—*pages 65 and 220*

CONTEMPORARY AMERICAN PAINTING
The Encyclopædia Britannica Collection (Duell, Sloan & Pierce)
Introduction by Donald Bear—Vol. XXI—also *page 38*

MODERN ART IN AMERICA by Martha Candler Cheney
(Whittlesey House)—*pages 129 and 132*

THE STORY OF MODERN ART by Sheldon Cheney
(The Viking Press)—*pages 589 and 591*

NEW FRONTIERS IN AMERICAN PAINTING by Samuel Kootz
(Hastings House)—*page 44, plate 30*

AMERICA TODAY
A book of 100 prints chosen and exhibited by
The American Artists Congress—*page 37*

ROMANTIC PAINTING IN AMERICA
Catalogue to the Exhibition at Museum of Modern Art
Introduction by James Thrall Soby—*page 42, plate 107*

AMERICAN PAINTING TODAY by Forbes Watson
(American Federation of Arts)—*pages 112 and 169*

THE PLASTIC ORGANIZATION OF PHILIP EVERGOOD
Article written in *Parnassus*, Vol. XI, No. 3, March, 1939
by Elizabeth McCausland—*pages 19, 20, 21*

chronological table of important reviews

ABBREVIATIONS

N.Y.H. Paris, 8/25/25—Georges Bal; N.York. Spring 1927—M. Pemberton; N.York. 10/19/27—M. Pemberton; N.Y.T. 10/13/27—Eliz. Cary; N.Y.E.P. 10/5/27; N.Y.H.T. 10/13/27; N.Y.T. 1/8/28 — Eliz. Cary; N.Y.T. 4/8/28; N.Y.T. 8/19/28; N.Y.T. 9/30/28; N.Y.T. 12/23/28; N.York. 1/12/29; N.Y.E.P. 12/21/29—Margaret Breuning; The World 12/22/29; N.Y.Amer. 12/22/29; N.Y.T. 12/22/29—Ruth Green Harris; Art News 12/21/29; N.Y.S. 12/28/29; N.Y.H.T. 12/22/29 — Carlyle Burrows; Chic.P. 12/24/29; N.Y.T. 12/9/31; N.Y.E.P. 12/19/31; Art News 12/19/31; N.York. 12/26/31—M. Pemberton; N.Y.T. 5/3/32; N.Y.T. 5/27/32 — Edward Alden Jewell; N.Y.S. 3/15/33; N.Y.T. 3/16/33 — Edward Alden Jewell; N.Y.E.P. 3/18/33—Mar. Breuning.

N.Y.H.T. 3/19/33—Carlyle Burrows; N.Y.T. 3/19/33 —E. A. Jewell; Art News 3/18/33; Art Dig. 4/1/33; The Villager 4/13/33; N.Y.E.P. 9/23/33; N.Y.T. 9/24/33; N.Y.S. 4/3/34—Henry McBride; N.Y.T. 6/10/34; N.Y.S. 10/13/34; N.Y.T. 1/25/35—Edward Alden Jewell; N.Y.W.-T. 1/26/35—Emily Genauer; N.Y.T. 1/27/35; N.Y.S. 1/26/35—Henry McBride; N.Y.E.P. 1/26/35 — Margaret Breuning; N.Y.H.T. 1/27/35—Carlyle Burrows; Art Dig. 2/1/35; Jackson Heights Herald, The Art Marts 2/7/35—R. U. Godsoe; Art in America in Modern Times, Exhibition Catalogue by Holger Cahill and Alfred H. Barr, Jr., 1935; N.Y.W.-T. 5/25/35; N.Y.T. 9/22/35; Chic.D.N. 10/24/35—C. J. Bulliet; Chic.D.T. 10/24/35—Eleanor Jewett; N.Y.T. 10/24/35; N.Y.H.T. 10/25/35.

Art Dig. 11/1/35; Chic.S.T. 11/3/35—James O'Donnell Bennett; N.Y.H.T. 11/12/35; N.Y.W.-T. 11/14/35—Emily Genauer; N.Y.P. 11/30/35—Jerome Klein; Art Dig. 12/1/35; N.Y.P. 12/21/35—Jerome Klein; Art Dig. 12/1/35; N.Y.S. 12/9/35; N.Y.W.-T. 12/21/35; Melbourne Herald 1935; N.Y.W.-T. 12/28/35 — Emily Genauer; N.Y.T. 2/9/35; N.Y.T. 3/1/36; The Denver Post 3/15/36—Donald J. Bear; N.Y.T. 3/4/36 — E. A. Jewell; N.Y.P. 3/7/36; N.Y.W.-T. 3/11/36; N.Y.P. 4/18/36—Jerome Klein; N.Y.T. 6/21/36; N.Y.W.-T. 6/20/36; N.Y.T. 6/28/36; N.Y.W.-T. 6/27/36; N.Y.T. 9/6/36; N.Y.P. 9/19/36; L.I. Daily Press 9/4/36; N.Y.W.-T. 9/19/36—Emily Genauer; Sunrise Times 9/18/36; N.Y.T. 9/20/36—Edward Alden Jewell.

N.Y.T. 10/11/36 — Edward Alden Jewell; N.Y.T. Long Island 10/16/36; The Courier 11/13/36; The Courier 12/4/36; N.Y.P. 11/14/36—Jerome Klein; N.Y.T. 11/15/36 — Edward Alden Jewell; N.Y.P. 12/5/36—Jerome Klein; N.Y.T. 1/6/37; Art Front 1/1937; The Bulletin of The Brooklyn Institute 1/23/37; The London Studio Jan. 1937—Peyton Boswell; Magazine of Art 3/1937; Parnassus 4/1937—Emily Genauer; N.Y.P. 4/10/37; D.W. 4/26/37—J. Klein; The Brooklyn Museum Quarterly, Vol. 4, No. 2 4/1937; Coronet 5/1937 — Harry Salpeter; N.Y.T. 6/27/37; N.Y.T. 5/16/37; N.Y.P. 6/19/37— J. Klein; The Argus (Melbourne) 7/10/37—Harold Herbert; The Herald Art Critic (Melbourne) 7/10/37—Basil Burdett.

The Herald Australian Paper 6/29/37—George Bell; The Herald (Melbourne) 7/30/37 — George Bell; Life 10/4/37 (p. 126); N.Y.S. 11/13/37; N.Y.P. 12/18/37; N.Y.T. 2/27/38—Edward Alden Jewell; N.Y.T. 2/24/38; N.Y.P. 2/26/38—J. Klein; N.Y.S. 2/26/38; N.Y.H.T. 2/27/38; N.Y.W.-T. 2/26/38—

Emily Genauer; N.York. 3/5/38 Coates; D.W. 3/2/
38—Jacob Kainen; Time Mar. 1938; Art Dig. 3/1/
38; Art and Artists of Today Nov.-Dec. 1937; N.M.
4/26/38; N.Y.P. 4/19/38; Direction 5/1938; N.Y.S.
5/4/38; N.Y.W.-T. 5/1938; N.Y.H.T. 5/4/38;
N.Y.W.-T. 5/7/38; N.Y.T. Magazine (Brooklyn-
Queens) 4/10/38; N.Y.P. 5/14/38—J. Klein; N.Y.P.
5/21/38; N.Y.T. 5/21/38—E. A. Jewell; Direction
7/8/1938; The Fight 6/1938; Art Dig. 6/1/38.

D.W. 9/5/38—J. Kainen; N.Y.S. 8/20/38; S.R.U.&R.
8/14/38—Eliz. McCausland; N.Y.P. 11/5/38; S.R.U.
&R. 1/29/39 — Eliz. McCausland; N.Y.P. 5/6/39;
N.Y.T. 6/4/39; Art News 5/6/39; Parnassus May
1939 — E. McCausland; Berkshire Even. Eagle
7/25/39; N.Y.T. 8/13/39 — R. G. Harris; N.Y.T.
9/3/39; N.Y.P. 10/21/39; N.Y.T. 1/7/40; S.R.U.&R.
3/24/40—E. McCausland; N.Y.T. 3/27/40; N.Y.T.
3/31/40; N.York. 4/3/40; Bklyn. Eagle 3/31/40;
N.Y.W.-T. 3/30/40—E. Genauer; N.Y.S. 3/30/40;
N.Y.P. 3/30/40—J. Klein; Russky Golos—Burliuk
3/30/40; D.W. 3/31/40; The New York Artist
4/1940; D.W. 3/26/40; Art Dig. 4/1/40; Art News
3/30/40; N.Y.H.T. 3/31/40—C. Burrows; Parnassus
April 1940—Eliz. McCausland.

S.R.U.&R. 5/26/40—Eliz. McCausland; The Studio
Sept. 1940 — Richard Carlin; N.Y.W.-T. 10/26-40;
Phila. Record 10/27/40; Christian Sc. Monitor
11/2/40; D.W. 8/14/40; K.G. 9/22/40; K.G. 10/4/40;
K.G. 11/6/40; Kalamazoo College Index 10/12/40;
K.G. 10/13/40; K.G. 11/26/40; Magazine of Art,
Nov. 1940, "Land of the Free" by Forbes Watson;
Magazine of Art, Dec. 1941, "Painters under Forty"
by Forbes Watson; K.G. 2/2/41; K.G. 2/16/41; K.G.
2/20/41; Kalamazoo College Index 1941; K.G.
3/6/41; K.G. 4/11/41; D.W. 4/9/41; N.Y.S. 4/10/41
—H. McBride; N.Y.T. 4/13/41; N.Y.T. 4/19/41—
E. A. Jewell; S.R.U.&R. 4/20/41—E. McCausland;
K.G. 5/4/41; Art Dig. 4/1/41—Boswell; Art News
8/1/41; N.Y.W.-T. 9/13/41—E. Genauer.

N.York. 11/29/41; Bulletin of Museum of Fine Arts,
Boston—Dec. 1941; Magazine of Art 12/1941; K.G.
3/4/42; N.Y.T. 1/7/42; Art Dig. 1/15/42; K.G.
3/4/42; S.R.U.&R. 2/22/42; N.Y.T. 2/15/42; Art
News Feb. 1942; Art Dig. 3/1/42; N.Y.T. 4/30/42;
Art Dig. 5/1/42; N.York. 6/27/42 Coates; Evening
Chronicle, Allentown, Pa. 9/20/42; Beth. Globe-
Times 10/29/42; Mag. of Art 11/1942; N.York. 10/
24/42; Art News 10/15/42; N.Y.S. 10/16/42; N.Y.T.

10/18/42 — E. A. Jewell; S.R.U.&R. 10/18/42 — E.
McCausland; D.W. 10/18/42—G. Baer; N.Y.W.-T.
10/17/42; N.Y.H.T. 10/18/42 — C. Burrows; N.M.
11/3/42; Art Dig. 11/1/42; K.G. 1942; D.W.
11/8/42; N.Y.T. 11/24/42; N.Y.S. 11/29/42—Russky
Golos 11/22/42; Art Dig. 11/15/42.

Art Dig. 12/15/42; Art News 12/1/42; Art News
12/15/42; The Morning Call, Allentown, Pa.
12/12/42; N.Y.T. 12/8/42; K.G. 12/9/42; N.Y.S.
12/7/42; N.Y.T. 12/20/42; Art News 1/1/43; N.Y.T.
1/24/43; Carnegie Mag. Jan. /43; The Working
Front—1943; Art News 3/1/43; S.R.U.&R. 3/7/43—E.
McCausland; Art News 4/1/43; N.Y.W.-T. 4/10/43;
N.Y.T. Book Review 4/25/43; Life, Oct. 25/43 (p.
13); Art News, Ruth Berenson, Dec. 1943; N.Y.T.
10/14/43; N.York. 12/11/43; Bklyn. Eagle 2/6/44;
Art News 2/15/44; Cue 2/5/44; N.Y.T. 2/15/44—
E. A. Jewell; Art News 3/44; Milwaukee Journal
3/5/44; Art News 3/15/44; Art Dig. 3/15/44; N.Y.S.
3/18/44 — H. McBride; Bklyn. Eagle 3/15/44;
S.R.U.&R. 3/19/44 — E. McCausland; N.Y.W.-T.
3/18/44; N.Y.T. 3/19/44; N.Y.H.T. 3/19/44—
C. Burrows.

D.W. 3/22/44; Newsweek 3/27/44; N.M. 3/28/44—
M. Soyer; N.Y.T. 3/26/44; N.Y.T. 4/30/44; Art
Dig. 5/15/44; N.M. 5/23/44—Moses Soyer; N.Y.
W.-T. 5/27/55; N.M. 5/30/44; N.M. 6/20/44; Art
News 8/1/44; Mirror 7/19/44; N.Y.T. 7/26/44;
N.Y.H.T. 7/26/44; P.M. 7/26/44; S.R.U.&R. 7/30/
44—E. McCausland; N.Y.T. 7/30/44; Newsweek
7/31/44; Art News 8/1/44; Art Dig. 8/1/44; U.M.
10/3/44; N.Y.H.T. 10/8/44; N.Y.T. 10/4/44;
N.Y.W.-T. 10/7/44; Art News 10/15/44; Pitts. Sun.
Tele. 10/12/44; Boston Herald 12/3/44; Art News
11/15/44; S.R.U.&R. 11/12/44; Art. Dig. 12/1/44;
Chris. Sc. Monitor 12/5/44; Jewish Advocate
12/7/44; N.M. 12/12/44; Russian Daily 11/12/44—
Burliuk; Art Dig. 1/15/45.

Art Dig. 2/15/45; S.U.R.&H. 2/18/45; N.Y.T.
2/25/45; N.York. 3/10/45; Newsweek 3/5/45; Art
News 3/1/45; Art Dig. 4/1/45; Time 6/4/45; N.M.
7/31/45; Newsweek 10/1/45; Esquire 10/1945—Sal-
peter; D.W. 10/21/45—Herman Baron; Art Outlook
10/25/45; Pitts. Sun 10/12/45; Limited Edition,
Pitts. 10/1945; Pitts. Post Gazette 10/12/45; Pitts.
Press 10/12/45; Art News 10/15/45; Art Dig.
10/15/45; N.Y.T. 10/14/45—E. A. Jewell; Time
10/22/45; N.Y.W.-T. 10/13/45; N.Y.T. 10/12/45—
E. A. Jewell; S.H.U.&R. 10/28/45—E. McCausland.